Wicked Women
of MISSOURI

Wicked Women of Missouri

Larry Wood

THE
History
PRESS

Published by The History Press
Charleston, SC
www.historypress.net

Copyright © 2016 by Larry Wood
All rights reserved

First published 2016

Manufactured in the United States

ISBN 978.1.46711.966.5

Library of Congress Control Number: 2015958235

CONTENTS

Acknowledgements

I would like to thank the reference department at the Joplin Public Library, particularly Patty Crane and Jason Sullivan, for filling numerous interlibrary loan requests for me. A number of other people also helped me in the research for this book in one way or another. These include Steve Weldon of the Jasper County Records Center, Marc Houseman of the Washington Historical Museum and Fred Pfister, former editor of the *Ozarks Mountaineer*. The various museums, libraries and other organizations that supplied photos for the book are acknowledged in the credit lines, but I would like to say thanks here, too, to those groups.

Thanks also go to The History Press commissioning editor Ben Gibson for his advice and encouragement as I researched and wrote this book and to production editor Katie Stitely for her excellent edit of the manuscript after it was complete.

Chapter 1

BELLE STARR,
QUEEN OF THE BANDITS

Belle Starr was known regionally during the 1880s as an aider and abettor of outlaws and even served a stretch in prison in 1883 for horse theft. But it was not until after she was murdered near Eufaula, Indian Territory (Oklahoma), on February 3, 1889, and dime novelist and *National Police Gazette* publisher Richard K. Fox released, later the same year, a highly romanticized version of her story, entitled *Bella Starr, the Bandit Queen; or, the Female Jesse James*, that she was catapulted to nationwide fame. Subsequent authors have repeated and embellished the outlandish legend ever since, to the point that Belle Starr is not just the most famous female outlaw of the Old West but is also one of its most noted figures of either gender. In fact, Belle's story was sensationalized, in part, precisely because she was a woman, and many of her supposed exploits rival or top those of her infamous male counterparts. The details of Belle Starr's life are sketchy, but the known facts show that her real story is interesting enough in its own right.

Belle was born Myra Maybelle Shirley on February 5, 1848, in rural northwest Jasper County, Missouri. Her father, John Shirley, was a prosperous farmer, but in the mid-1850s, the family moved to Carthage, the county seat, where Shirley established a hotel on the north side of the courthouse square. Shirley also rented horses and hacks from an adjacent livery, and a blacksmith shop was attached to the livery. His buildings took up almost the whole north side of the square.[1]

After the family moved into town, Myra enrolled in the Carthage Female Academy, and she was considered one of the school's better students, quickly

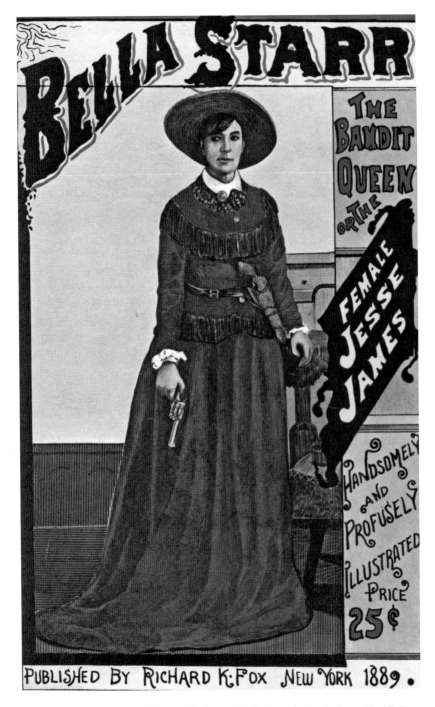

A facsimile of the cover of Richard Fox's 1889 *Bella Starr, the Bandit Queen. From* Bella Starr, the Bandit Queen.

mastering its classic curriculum and also learning to play the piano. As a girl, Myra also attended a private school, conducted by William Cravens, held on the second floor of the Masonic Hall in the Carthage public square. A former schoolmate remembered many years later that Myra was bright and intelligent but had a fierce nature and was willing to fight anyone, boy or girl, with whom she got into a disagreement. Myra was often asked to perform on the piano, and many people flattered her for her musical performances and other accomplishments. She grew somewhat vain and was known by some of her schoolmates as Carthage's little rich girl. Another acquaintance, however, remembered Myra as "rather a pretty girl" whom everybody liked.[2]

A competent horsewoman, Myra enjoyed riding about the countryside with her elder brother John Allison, usually called Bud. He reportedly taught her how to handle a rifle and a pistol. When the Civil War came on, the Shirley family sided with the South. Bud joined up to fight for the Rebel cause and soon became a member of an irregular guerrilla band.[3] Two well-known legends about Belle Starr that arose posthumously involve her activities surrounding her beloved brother's Civil War service.

According to the first legend, Myra was out on a scouting expedition for her brother Bud and his guerrilla pals in early February 1862. As she was returning home, she passed through Newtonia, thirty-five miles from Carthage, on her sixteenth birthday and was detained by Major Edwin B. Eno. One of the guerrillas' biggest nemeses in southwest Missouri, Eno had sent a detachment toward Carthage in search of Bud and his comrades, and he knew that Myra was on a mission of espionage.[4]

The girl was held in an upstairs room of the Mathew Ritchey mansion, which Eno was using as his headquarters. The room was furnished with a piano, which Myra supposedly played during her captivity. At last, Eno, thinking his men had had ample time to reach Carthage, released Myra, taunting her as he did so by telling her that her brother was likely under arrest by now. Myra rushed out of the house, cut a sprout from a cherry tree to use as a riding whip and quickly mounted her trusty steed. She galloped away, using the switch to urge the horse onward. Taking a shortcut, she left the main road to cut across country and miraculously reached Carthage ahead of the Federals to warn her brother and his friends of their approach. When the Union soldiers rode into town a half hour later, Myra was there to greet them with a smile and to inform them that "Captain Shirley" and his men were long gone.[5]

About the only part of this tale, first promulgated in Samuel W. Harman's 1898 *Hell on the Border*, that can be substantiated by primary sources is the fact

that Major Eno was stationed at Newtonia during the Civil War. But even in this particular, Harman got the date wrong; Eno did not arrive on the scene in Newtonia until 1863. The rest of the story seems to be fantasy. Even if Myra did sometimes spy for her elder brother in the immediate Carthage area, it seems unlikely that a fifteen-year-old girl would have ventured thirty-five miles from home by herself on such a dangerous mission. Some of this story is demonstrably untrue, such as the idea that it occurred on Myra's sixteenth birthday, and all of it smacks of romantic nonsense.

The other well-known Belle Starr legend stemming from her time as a girl in Missouri during the Civil War involves Bud's death. One day during the summer of 1864, Bud and another guerrilla, Milt Norris, were taking a meal at the home of a Southern sympathizer named Mrs. Stewart in Sarcoxie when a detachment of Federal militia surrounded the place. A woman who lived nearby stated many years later that both men dashed out of the house to make a run for it and that Bud Shirley was shot and killed as he leaped over a fence, falling dead on the other side. Norris was wounded but managed to escape and carry the dreaded news to the Shirley family. The next day, Myra Shirley and her mother came to Sarcoxie to claim the body. With two big pistols swinging from a belt around her waist, Myra "was not timid in making it known among those she saw that she meant to get revenge for her brother's death."[6]

Another version of this tale, one that seems to be less grounded in fact, has Myra coming into Sarcoxie accompanied by her father, not her mother. As Mr. Shirley carried Bud's body from the Stewart house and loaded it on to his wagon, Mrs. Stewart brought out Bud's holster and revolver and laid it on the seat of the wagon beside Myra; the local militia stood nearby overseeing the proceedings. John Shirley went to the Stewart shed to retrieve Bud's horse, and when he returned and began hitching the animal to the tailgate of the wagon, he noticed his daughter had picked up Bud's pistol, still in its holster. "Put down the gun, May!" he said.

Disregarding her father's warning, Myra snatched the pistol from the holster, and all the bystanders scattered in panic. Before Mr. Shirley could reach his daughter to intervene, she leveled the revolver at the militiamen and started rapidly thumbing the hammer, but the only sound was a metallic click because the militiamen had taken the precaution of removing the caps. Myra started bawling in anger and humiliation, and the militiamen had a good laugh at her expense as the Shirley wagon pulled away.[7]

As the Civil War progressed, Missourians of Southern proclivity often found their state an increasingly inhospitable place to live, and many of

them migrated to Texas. Not long after the death of his son Bud, John Shirley joined the exodus, loading up his belongings and moving the rest of his family to the Lone Star State. The Shirleys settled on a farm near Scyene, about ten miles southeast of Dallas, where John's eldest son, Preston, and a number of other Missourians had previously relocated.[8]

According to legend, several members of the James-Younger outlaw gang absconded to Texas in 1866 after a bank robbery in Missouri and stayed briefly with the Shirley family. Cole Younger supposedly used the opportunity to seduce pretty Myra Shirley, and the torrid romance produced an illegitimate child, whom Myra named Pearl. Some Belle Starr biographers have even insisted that she and Cole Younger were briefly married. After Belle's death, Cole Younger said he'd had a slight acquaintance with her years earlier. He admitted that he'd visited the Shirley family in Texas, although he placed the year as 1864 while the war was still going on, not 1866 after it was over. He strongly denied, however, that he'd ever been married to Belle or had a romance with her. Younger's disclaimers didn't keep fanciful writers from perpetuating the myth.[9]

In truth, Myra Shirley did fall in love with and marry a former Missouri guerrilla, but his name was Jim Reed, not Cole Younger. Reed was from the Rich Hill area of Bates County, about fifty miles north of Carthage, and had apparently known the Shirleys in Missouri. He renewed the acquaintance after his mother and siblings relocated to Texas following the death of his father, Solomon Reed, in 1865. Reed and Myra M. Shirley were married in Collin County, Texas, on November 1, 1866.[10]

After the wedding, Reed and his new wife stayed near Dallas for a while, but by late 1867, they were back in Missouri, having accompanied Jim's mother and siblings upon their return to Bates County. For most of 1868, when many biographers have Myra playing piano in Dallas dance halls and galloping about the streets of the town on her fiery horse, she was in Missouri with her mother-in-law's family.[11]

Jim Reed, however, was seldom home. He soon fell in with a gang of ne'er-do-wells at Tom Starr's ranch in Indian Territory, seventy miles west of Fort Smith on the Canadian River. A Cherokee Indian, Starr had been pardoned after killing several Anti-Treaty Party Cherokees in retaliation for the killing of his father, but he was still considered a desperado. His place had become a resort for outlaws like the James and Younger brothers. Starr had even named the area where his ranch was located, in a crook of the Canadian River, Younger's Bend in honor of Cole Younger.[12]

Over the next few years, Reed was implicated in several crimes, and Myra followed her wayward husband to California, then back and forth

between Texas and Indian Territory, as he tried to stay one step ahead of the law. Some biographers have her participating in some of Reed's crimes and cavorting about Dallas in outlandish garb, frequenting the gambling houses and saloons and, occasionally, shooting up the place for no particular reason. The contemporaneous evidence suggests that both claims are pure fiction.[13]

After Reed was killed in 1874 by a special deputy who had infiltrated his gang, Myra, according to early biographers, supposedly pulled off another string of daring adventures in Texas and Indian Territory, but the best evidence suggests that she stayed on at her parents' home near Scyene for at least the first year or two. After her father died in 1876, she made a sojourn to Arkansas and then, around 1879 or 1880, paid a visit to her old hometown of Carthage. She spent time in the nearby mining towns of Joplin, Missouri, and Galena, Kansas, where she took up with desperado Bruce Younger, a kinsman of the notorious Younger brothers. Myra's supposed adventures with Younger have been the subject of speculation, and the question of whether the two were ever officially married has been especially debated. Skeptics are right to doubt many of the Belle Starr yarns, whether they are attached to the name of Bruce Younger or anyone else, but the issue of whether the couple was ever officially married can be laid to rest. Marriage records of Labette County, Kansas, show that Bruce Younger wed Maibelle Reed in Chetopa on May 15, 1880.[14]

The marriage, however, was short lived. Almost immediately after the exchange of vows, Myra left for Indian Territory, where she renewed her acquaintance with Tom Starr and particularly with his son Sam. She and Sam Starr were married in the Canadian District of the Cherokee Nation on June 5, 1880, just three weeks after her marriage to Younger. She would ever after be known as Belle Starr.[15]

Although outlandish tales about Belle arose posthumously asserting that she became the leader of an outlaw gang shortly after marrying Starr, the truth is that she and Sam lived in relative peace for the first couple years of their marriage and did not run afoul of the law until mid-1882, when they were charged with the theft of two horses from their neighbors Andrew Crane and Samuel Campbell. Appearing before Judge Isaac Parker in February 1883, Sam was found guilty in the Crane case, and Belle was found guilty in both the Crane and Campbell cases. Showing a leniency that belied his moniker as the "hanging judge," Parker sentenced Sam to one year and Belle to two six-month terms at the House of Corrections in Detroit, with an opportunity for release after nine months.[16]

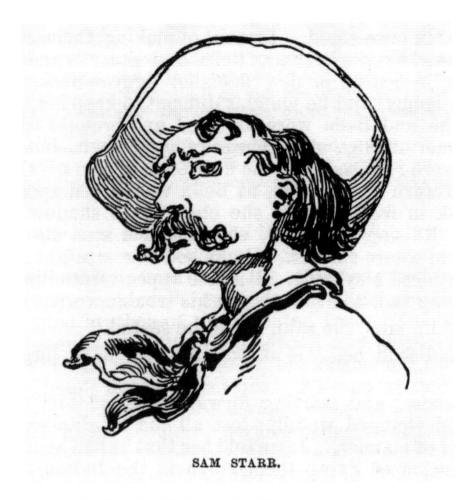

SAM STARR.

A sketch of Sam Starr. *From* Bella Starr, the Bandit Queen.

At the time of the sentencing, the *Fort Smith Wheeler's Independent* remarked that the case was interesting because of the "history and former associations" of Sam and Belle Starr, mentioning in particular the bloody legacy of Sam's father, Tom. "Belle," the newspaper continued, "is a remarkable woman, and is said to have an eventful history. She is a magnificent equestrienne, has taken all prizes where she competed for riding, and is a fine pistol shot…and is young and good looking enough to charm the heart of a desperado." There seemed to be a difference of opinion about Belle's beauty. Unlike the *Independent*, the *Fort Smith New Era* thought Belle could not be considered a good-looking woman, but the editors admitted her appearance was of the kind "to attract the attention of wild and desperate

characters." Regardless of Belle's physical assets, the most remarkable aspect of the robbery case, the *New Era* opined, was the simple fact that a woman was involved. "The very idea of a woman being charged with an offense of this kind and that she was the leader of a band of horse thieves and wielding a power over them as their queen and guiding spirit, was sufficient to fill the courtroom with spectators."[17]

Belle Starr was, as the *Independent* asserted, a strong, outdoor woman who, at the same time, had a refined background. But the notion that she was the queen and leading spirit of a whole gang of horse thieves at the time of the legal proceedings against her in 1882 and early 1883, as the *New Era* charged, is a stretch. The name of Belle Starr would not become widely known until after she was killed in 1889, but local and regional newspapermen had already started spinning romantic yarns about her six years earlier.

After Sam and Belle were released from prison in late 1883, they returned to Younger's Bend and lived in relative tranquility for the first year. However, around Christmas 1884, John Middleton, a cousin of Jim Reed and a fugitive wanted for the murder of a Texas sheriff, showed up at their house. Sam Starr hid him out in the wilds of the Canadian River for a while but soon grew nervous about continuing to harbor him. Belle agreed to help get the fugitive out of the territory in the spring of 1885. She procured a horse for Middleton from a man who didn't bother to tell her the animal wasn't his. In early May, the horse was found near a river southwest of Fort Smith, and the body of Middleton, who had apparently died crossing the stream, was found nearby. In early 1886, Belle was charged with horse theft in the case. Appearing at Fort Smith, she pled not guilty and was released on bond, but she had scarcely returned home when she encountered trouble again. In late February, Sam Starr and several other men allegedly robbed about forty dollars from the Farrill residence in the Choctaw Nation, and Belle, according to one dubious newspaper report, participated in the holdup dressed as a man. She was later charged with being the leader of the gang, arrested in mid-May and taken back to Fort Smith to answer the new charge against her.[18]

Belle again pled not guilty, saying she could prove she was at a barn dance in Briartown on the night of the robbery. She gave bond and spent the next few days visiting friends and shopping in Fort Smith. On May 23, she was photographed for a St. Louis newspaper mounted sidesaddle on a horse, and the next day, she had her picture taken with Blue Duck, a Cherokee Indian under death sentence. Some biographies of Belle Starr claim she and Blue Duck were romantically involved, but the evidence suggests that Belle only

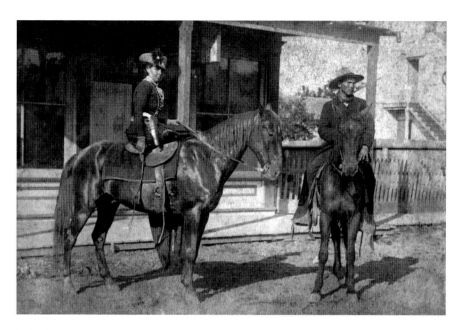

Belle Starr on horseback alongside U.S. deputy Tyner Hughes in Fort Smith, 1886. *Courtesy Wikipedia.*

had her picture taken with him as a favor to her lawyer, who also represented Blue Duck. On or near the same day Belle posed for the photograph with Blue Duck, a Fort Smith correspondent wrote a story about her that later appeared in newspapers across the country. Supposedly based on the writer's interview with Belle, it described her as a "dashing horsewoman" who was "exceedingly graceful in the saddle," and it added that she was "well formed" with dark brunette hair and "bright and intelligent black eyes." The piece was otherwise full of mistakes and half-truths, and it became the basis for much Belle Starr foolishness. When Belle reappeared in court in late June, the charges against her in the Farrill case were dismissed for lack of evidence.[19]

In late September, Belle was also found not guilty in the horse stealing case. In early October, she convinced her husband to turn himself in to federal authorities at Fort Smith rather than face Indian justice. Sam was charged with one count of burglary and released on bond. An annual fair was taking place in Fort Smith while the couple was there, and Belle was recruited to give a shooting and riding exhibition as part of the fair's Wild West show. Her participation reportedly proved to be quite a drawing card.

In November, Sam's case was continued until February 1887, and he and Belle returned home. On December 17, 1886, they attended a Christmas

dance just south of the Canadian River, and Sam got into a heated argument with Indian law officer Frank West. They ended up drawing their pistols and killing each other in an exchange of fire.[20]

After Sam Starr's death, Belle was no longer considered a Cherokee citizen and was subject to eviction from Younger's Bend. To avoid removal, Belle took in twenty-four-year-old Bill July (alias James July Starr) as her common-law husband. A mixed-blood Cherokee, July was a sort of adopted son of Tom Starr. Belle let it be known that her place was no longer a refuge for fugitives, and she was accepted into the good graces of federal and Indian authorities.[21]

A white man named Edgar Watson, who had immigrated with his wife to the Choctaw Nation south of the Canadian in early 1888, rented some land from Belle late the same year with an agreement to move onto the land in December. During the interval, Belle became friends with Watson's wife, who let it slip that her husband was wanted for murder in Florida. Alarmed that she might again be caught harboring fugitives, Belle tried to refund Watson's rent money, but he refused. She then mailed him the money with a letter explaining she had arranged for another man, Joseph Tate, to sharecrop her land. Watson scared Tate out of the deal, though, by warning him of Belle's lawless activities. When Watson came to discuss the letter and the rent refund Belle had sent him, she angrily confronted him about interfering in her business dealings, and she let it be known that she knew about his Florida troubles. Watson left without another word and moved into a tenant cabin owned by Jackson Rowe south of the Canadian, near where Belle's son, Eddie Reed, was also staying.[22]

On the morning of February 2, 1889, Bill July set out for Fort Smith to answer an 1887 charge of horse stealing that was pending against him, and Belle accompanied him part way. The couple spent the night about twenty-five miles southeast of Younger's Bend on the south side of the Canadian and then parted ways the next morning, with July continuing to Fort Smith and Belle heading back home. About four o'clock in the afternoon, Belle stopped at Jackson Rowe's house, hoping to see her son. Eddie was not there, but several other people were, including Edgar Watson. As soon as Belle rode up, Watson got up and left in the direction of his cabin about 150 yards away. After visiting a half hour, Belle mounted up and rode on toward home. About 300 yards beyond the Watson cabin, someone shot her from ambush with two blasts from a double-barrel shotgun. Belle was buried on February 6 in front of her cabin overlooking Younger's Bend with many mourners in attendance,

A sketch depicting Belle Starr's assassination. *From* Bella Starr, the Bandit Queen.

including Edgar Watson and his wife. After the funeral service, Watson was arrested and charged with murder, but the U.S. commissioner hearing the case ruled there was not enough evidence to proceed to trial

and ordered the defendant released. Other suspects were subsequently mentioned in connection with Belle's murder, but no one else was ever charged.[23]

In the days and weeks after Belle's murder, numerous stories appeared in newspapers throughout the country announcing her demise and summarizing her extraordinary life. One account claimed that "Belle Starr was, without exception, the most desperate woman that ever figured on the American border." Belle had supposedly been commander of a gang of thieves and outlaws, and "her escapes from death or capture on several occasions were almost miraculous." In conclusion, the report said, Belle "could swear like a sailor, ride a horse as good as a Texas ranger and shoot as quickly and accurately as a man from Arizona."[24]

That was tame stuff in comparison to many of the other outlandish stories published in the wake of Belle's death. Her murder quickly turned Belle, already a figure of some notoriety during her lifetime, into the most infamous woman of the American West. The legend, fueled particularly by the Fox biography later in 1889, continued to grow in the ensuing months and years to the point that she became not just the most notorious woman of the nineteenth century, as one posthumous report called her, but one of the most notorious of any century.

ALL THE PRETTY HORSE THIEVES

An unusual outbreak of horse stealing by young women occurred in the southwest Missouri area during the early 1890s, providing just the kind of scandalous material that sensationalist journalists of the time thrived on. The stories of two of the young women, in particular, made headlines across the country.

The first of the two on the scene was Della Oxley, who wrote her name in the annals of horse thievery in 1891 when she was about twenty-one years old. Born Ida Della Hoober in Indiana in 1870, she and her family moved to Kansas in the late 1870s and took up residence at Arkansas City in Cowley County, southeast of Wichita.[25]

In 1888, Della—or Delia, as she was sometimes identified in newspaper stories—married Perry W. Oxley in Kingman County. Returning to Della's hometown of Arkansas City, both Della and her husband were indicted in police court on charges of prostitution in the summer of 1890. Della pled guilty and was fined ten dollars and costs, while her husband pled not guilty and was turned over to the state to answer other charges.[26]

About a year later, the couple drifted into southwest Missouri, and Della promptly got into trouble with the law there as well. In the summer of 1891, she was arrested in Jasper County and charged with burglary and larceny for stealing a horse on the night of July Fourth near Medoc in the northwest corner of the county. She was taken to the county jail at Carthage, and her case came to trial on Saturday, October 24. The jury first came back with a verdict of guilty on the burglary charge and sentenced her to three years in

the state penitentiary at Jefferson City, but the judge disallowed the verdict, instructing the jury that, if they found the woman guilty of burglary, they must also find her guilty of larceny. The jury went back into deliberation on Saturday evening and came back with a verdict of guilty on both charges and a sentence of five years in the state prison.[27]

According to one report, when Della heard the verdict, she exclaimed that the judge, jury and prosecuting attorney could "kiss her foot and go to Sheol." After Della's anger subsided, she reportedly grew despondent and threatened to commit suicide.[28]

When court adjourned, Della was led back to the female quarters of the county jail, a second-floor room in the front part of the building. At ten minutes 'til one o'clock on Sunday morning, she asked the night watchman what time it was, confirming that she was still in her cell at that time. But when the jail officers went to take her breakfast about eight hours later, "they found that, like the sweet voiced bird, she had flown." The windows of the guard room had bars across them, but they were not very close together. Della had made her escape by sawing one of the bars in two, climbing through the opening and dropping or rappelling to the ground below. It was supposed that one or more persons had helped her carry out the escapade by supplying her with a saw and otherwise abetting her getaway. Informed of the escape, the Jasper County sheriff offered a fifty-dollar reward for the fugitive's recapture.[29]

In reporting the young woman's escape, Della's hometown newspaper, the *Arkansas City Daily Traveler*, called her a "notorious, fearless and dangerous highway robber and burglar" and claimed that eight to ten men were scouring the county in pursuit of her. "Her career," the newspaper concluded, "has been one of crime only, so far as known." A different newspaper described Della as having "a villainous look" and mentioned that her husband was also in jail at Carthage at the time of her escape.[30]

Della had, indeed, apparently contemplated taking her own life because, after her escape, a suicide note was found in her empty room. It read:

To…whom it may concern, I go from here to a watery grave and god have Pitty on my Soul—But I would rather go there than to Jefferson. Don't make it known any more than you can help—Please to keep it from my Poor old Mother and all my dear Sisters and Brothers. Oh my god, why Oh why is it that men is so hartless—I say it now, and I am as good as dead, that I am inicent. But then someone has got to suffer and it fell on me as the one. But I will cheat them yet, Even though I send my Soul to Hell. So

Please have Pitty on me and if [my] *Body is found, give it to my mother and the only man I Ever did love, my own long suffering Perrey. Oh my hart—it is hard hard, Oh so hard to have to Part with him and say, Babe, Oh my all, a Baby, god bless her and I hope he will forgive her Poor mother for what I am about to do—Oh my god my god, I have been all my life a stumbling block in the way of others, so now I am going to Do what others has done Before me.*

So good by to you all.
Della Oxley

The *Carthage Evening Press*, however, dismissed the letter as merely an attempt on Della's part to "establish the suicide theory."[31]

After her escape, Della made her way to Baxter Springs, Kansas, just across the state line from Jasper County. Arriving on Monday morning, October 26, she "proceeded to take in the town," according to the *Baxter Springs News*. Among other activities, Della reportedly had her picture taken and mailed to a friend in Arkansas. She had cut her hair short not long before her escape from jail, and when she arrived in Baxter Springs, she was dressed in men's clothes and, according to the *News*, "presented the appearance of a smart, smooth-faced young man."[32]

The clothes Della was wearing upon her arrival in Baxter Springs were, according to one report, "not good enough to suit her fastidious taste," and it was her effort to upgrade her wardrobe that led to her recapture. She went to a clothing store in Baxter and bought a pair of trousers and a cowboy hat, but in changing trousers, she left a letter that was addressed to her in the old pair of trousers. The letter aroused the suspicions of the storekeeper, and he notified two Baxter Springs law officers, who located Della about eleven o'clock that night asleep in bed. They had little trouble making the arrest, although one of the officers wasn't sure whether the suspect was a woman. The other one supposedly exclaimed that he could tell the difference between a man and a woman even in the dark and proceeded to put the handcuffs on Della.[33]

After she was placed in the Baxter Springs jail, Della admitted she was the woman who had escaped from Carthage, and the next day, a Jasper County jailer and a sheriff's deputy came to Baxter Springs to take charge of the fugitive. Bidding adieu to Mrs. Oxley, the *Baxter Springs News* claimed she was a notorious burglar and thief who had "broken out of several different jails." The *Joplin Morning Herald* referred to her simply as "the female horse thief."[34]

DELLA OXLEY CAPTURED.

The Convicted Thief who Broke Jail at Carthage Apprehended at Baxter Springs.

Della Oxley, the female horse thief who broke jail at Carthage last Saturday, has been captured. The woman was convicted in circuit court last Saturday on a charge of burglary and larceny and sentenced to the penitentiary for five years.

A headline announcing Della Oxley's recapture. *From the* Joplin Morning Herald.

Upon her return to Carthage, Della was assigned to her old quarters in the front part of the jail, but she was securely chained to the floor. On November 4, officers discovered that her shackles had been filed almost in two and that only a little additional work would have been required for her again to be at liberty. The sheriff told her he was going to have to put her in the dungeon and prefer charges against her for jail breaking and that her sentence would probably be doubled. The threat induced her to give away her cohorts, and warrants were immediately sworn out for the arrests of James Belkamp and Fat Hurst, who Della said aided her first escape, gave her money to live on and were helping her prepare for another jail break. Belkamp was an ex-con who had spent time in prison as an accomplice to murder, and Hurst had been seen sneaking into the jail shortly before Della's latest escape attempt was discovered. Both men were promptly arrested and lodged in jail at Carthage to await trial on charges of aiding a prisoner to escape.[35]

On November 11, Della was shipped to Jefferson City to begin serving the five-year term that she had been previously assessed. The *Kansas City Star* called her at the time "a leader in the biggest criminal circles in Jasper County." A correspondent to the *Fort Worth Gazette* gave readers an even more exaggerated and inaccurate description of Della Oxley, starting with the fiction that she was thirty-six years old and was born "in a New England village." In addition, Della was supposedly "of criminal parentage" and had

become "a hardened criminal" when she was only twelve years old. The *Gazette* correspondent continued his extravagant account:

> She drifted to the West and organized a band of horse thieves and burglars, which had for its range the states of Kansas and Western Missouri. For the past ten years these robbers have been living off of the farmers of this section, and all the raids and burglaries were planned by the woman, Della Oxley. She has gone with a number of the members of the band as far West as California, and after committing a series of depredations, has returned to her old haunts, and no trace of her was left behind. The horses which were stolen by the band were run off to a far market and all trace of them hidden.[36]

In truth, Della was only twenty-one years old, not thirty-six, and ten years earlier she was not organizing a gang of burglars and horse thieves, at least not in Kansas and Missouri, since she was an eleven-year-old girl living in Indiana with her parents at the time.

Della was released from the Missouri State Penitentiary on August 13, 1895, under the state's three-fourths law. The following January, Perry W. Oxley filed for a divorce from Della in Sedgwick County, Kansas. Later in 1896, Della was remarried to Truman J. Reynolds in Edwardsville, Illinois, and she died in Taylorville, Illinois, in 1898 at the age of twenty-eight.[37]

LESS THAN TWO YEARS after Della Oxley had been sent up the river, May Calvin appeared on the scene in southwest Missouri to take up where Della had left off in the work of horse thievery. May's exploits were sensationalized in the press even more than Della's, and she eventually joined her predecessor at the big house in Jefferson City.

Although the facts surrounding May's origins are sketchy, evidence suggests that she might well be the five-year-old May Calvin listed in the 1880 census of Miller County, Missouri, living in the household of her grandmother. What is known with some confidence about May is that she moved from Thayer, Missouri, to Webb City, Missouri, around 1890, when she was about fifteen years old. (Even May's exact name is in doubt, as her first name sometimes appears as Mary and her last name as Colvin.) According to one report, May had already turned to crime while still living at home. When her stepfather became abusive in an effort to control her, she fled Thayer on a horse stolen from a neighbor's barn in order to escape the harsh discipline. An alternate, and more likely, story is one that she partially

confirmed herself—that she came to Webb City to attend school, although it seems plausible that her leaving home might not have been altogether voluntary but instead that she was sent away as incorrigible.[38]

After a brief time in Webb City, May, who was said to have developed a love of horses at an early age, dropped out of school and joined Robinson's Circus in St. Louis as a rider. Before long, however, she came back to southwest Missouri and soon drifted across the state line into Kansas, where she went on a criminal spree.[39]

A newspaper sketch of May Calvin. *From the* San Francisco Chronicle.

About mid-October 1892, May stole a horse and buggy from a livery at Fort Scott and immediately started south. She was captured in Weir City on October 18, still in possession of the horse, although she had disposed of the buggy. She was brought back to Fort Scott and placed in the Bourbon County jail. However, her youth and good looks reportedly won her the sympathy of the prosecuting attorney and the judge, and the case against her was dismissed on January 21, 1893.[40]

Less than twelve hours after gaining her freedom, an unrepentant May appropriated a horse and buggy from a barn near Hepler in Crawford County, Kansas, and drove back to Fort Scott with what one report called "insane daring." After calling on some of her friends at Fort Scott, she "drove furiously" to Nevada, Missouri. There she left the stolen rig at a livery as security for another horse and buggy and then resumed her mad dash. The day after she passed through Nevada, a posse that had gone out in pursuit finally intercepted her and placed her in the custody of the Vernon County sheriff. Shortly afterward, he turned her over to the authorities of Crawford County for the Hepler heist, and she was placed in the county jail at Girard.[41]

May's stint in the Crawford County jail proved brief, however. Sometime in March or April, she either escaped, as she later claimed, or was again released, as at least one newspaper report stated. On May 1, she turned up in Joplin, Missouri, where she once again resorted to her old tricks. Calling at the livery stable of W.V. White, she hired a horse and buggy for the stated purpose of driving to East Joplin, but, as she was wont to do, she conveniently forgot to return the rig. Around June 1, White recovered his stolen horse from a herd being driven through Joplin, but there was no sign of his harness and buggy, nor of May Calvin. Then, on June 5, May was arrested in Columbus, Kansas, for disturbing the peace. Knowing she was wanted in Missouri, the local officers held her until a Joplin constable, warrant in hand, showed up on June 7 to take charge of her and escort her back to Joplin, where she appeared before a justice of the peace the same day. Unable to put up a $1,000 bond, the justice ordered her committed to the Jasper County jail to await the action of a grand jury. Taken to Carthage, she was placed in the same second-floor room where Della Oxley had been housed in 1891. Meanwhile, White's buggy and harness were located in Columbus, and the liveryman trekked to Kansas to retrieve them.[42]

May was charged with grand larceny, but before she could be tried, she and a fellow female inmate made a daring escape from the county jail on June 16, 1893. "The county jail this morning contained two less toughs

DUG OUT WITH SCISSORS

May Calvin and Mary Medsker Escape From Jail.

MAY IS A NOTORIOUS HORSE THIEF.

That They Were Missing Was Discovered at Two O'Clock This Morning—Apparently Had Help From Outside.

A headline announcing May Calvin's jailbreak. *From the* Carthage Press.

of the female persuasion than it did last night," said the *Carthage Press* in reporting the escapade. "The missing birds are May Calvin, the notorious horse thief, and Mary Medsker, the all-around bad character, who has been in jail here many times within the last few years."[43]

According to the *Press*, the two women made their escape through the same opening "commenced two years ago by Della Oxley, the female horse thief who made herself so notorious about that time." May and her companion tore their blankets into strips and fashioned a rope, which they tied to the bars of their room and used to lower themselves to the ground below. Two other female prisoners housed in the room with them at the time gave an alarm about 2:00 a.m., claiming they had no prior knowledge of the escape and had just now awakened to discover May and Mary gone. Despite

receiving timely notice of the women's disappearance, officers had no clue as to "which way or where they went."[44]

A posse went out in pursuit of the two fugitives, and a day or two after the escape, the deputies came upon May resting in a dense thicket of a swamp on the border of Indian Territory (now Oklahoma). The horse she was riding had reportedly become exhausted, and she offered no resistance when the posse overtook her.[45]

May was taken back to Carthage and, once again, locked up. On June 22, she was taken to Joplin and arraigned in circuit court for horse stealing. She pled guilty and was assessed a punishment of two years in the state penitentiary.[46]

The *Carthage Press* described May's bearing and appearance as she left for Joplin that morning and as she returned later the same day:

> *She wore an old red wrapper that gave her a very flowing and distingue appearance and a Maud Miller hat that had been run over by a freight train. Her bold, open countenance wore a beaming smile that betokened total indifference to the clutches of the law, and as she returned to the jail after the sentence, she gave off a merry horse laugh and said to a* Press *reporter, "I only got two years. 'Tain't much, you know it. I'll be a good girl at the pen and get out in eighteen months. Write me up right."*[47]

The *Press* reporter obliged her, doing his best to "write her up right," as the following description suggests:

> *May Colvin has attained much undesirable notoriety, though only twenty years of age, and there are some very interesting points in her career. She began horse stealing at the age of sixteen years, and has made that her vocation not so much for gain as for the love of horses. She has been almost constantly a refugee or a prisoner for the last four or five years and has eluded the officers very adroitly in several cases. She was arrested for horse stealing in Kansas and jailed at Fort Scott. She pleaded guilty and the case against her was nollied. She went right out and continued her career of thieving and now goes to the penitentiary for the first time, though she has stolen dozens of horses and vehicles—how many is unknown.*

The fact that May was only about eighteen, not twenty as the *Press* reporter said, casts serious doubt on his claim that she had been a refugee or a prisoner for the past four or five years. His statement that she had stolen "dozens" of horses was very likely a wild exaggeration as well.

However, the Carthage newspaperman's embellished account was fairly tame compared to some of the incredible stories about May that appeared elsewhere. As the *Press* reporter himself pointed out, May had become "the subject of a good deal of sensational reading matter in the various newspapers of the West."[48]

May was transferred to the state penitentiary on June 25, but the stream of marvelous stories about her exploits continued. One Missouri newspaper observed that Jasper County now had two female convicts at Jefferson City but that May Calvin and Della Oxley were "not harmonious as they should be and want to fight each other all the time." May made headlines not only in Missouri and the Midwest but across the country and even internationally. For instance, one newspaper story, written after May had made her escape from the Jasper County jail but before she had been recaptured and sent to prison, was first published in the United States and was later picked up by the *Wellington Evening Post* of New Zealand. Calling May "the phenomenal girl horse-thief," the story said her career "surpassed anything of the kind before known" and claimed that she had turned to horse theft not because of an incorrigible criminal tendency but "because of her passionate love for horses, which seems to have complete control of all her faculties and energies." May, the story continued, had won leniency because of "her innocent ways and attractive appearance, together with her youth." The story concluded that May had an "almost inconceivable passion for horses" and that she was only satisfied when she was "driving, riding, or caressing them." In all other matters, she was considered "perfectly sane and more than ordinarily intelligent."[49]

The stories about May continued long after she had been sent to the state prison. In 1894, a reporter for the *St. Louis Republic* visited May at the Jefferson City facility and wrote a fantastic story entitled "A Beautiful Horse Thief." The newspaperman's description of May's physical appearance bordered on the titillating. Calling May "pretty as a picture" and "a rustic beauty," the writer claimed that if she were dressed "in the gorgeous paraphernalia of Lillian Russell…, she would be a more brilliant beauty than that stage celebrity. She has great blue eyes and a mass of tousled hair of Titian hint. Her form is luscious—well rounded and plump—and her cheeks are red with the vigorous life of the Ozarks, whence she came. Her mouth is one that an impressionable artist would go wild over, with its cherry red lips of sensuous curves, the whole forming the most perfect Cupid's bow."[50]

When interviewed by the *Republic* reporter, May did not try to deny her crimes. "Well I have no hard luck story to tell," she told him. "They made

no mistake in my case. Nearly everybody else in here is innocent, according to their own statement, but I'm not. I'm here for horse stealing."[51]

May told the reporter that, when she heard someone was at the prison to see her, she first thought it was probably a law officer from Girard, Kansas, who wanted her for breaking jail there. She said she was glad to learn otherwise but that she still figured an officer from Kansas would come for her when her time was up in the Missouri pen.[52]

May said that she had been "a pretty good girl" since she had been in prison, but she had still managed to get herself placed in "the dark room" two or three times. She vowed to behave herself from then on, however, so she could get the benefit of the three-fourths rule. May said she didn't know why she had turned out so bad, unless she was just born that way, because her mother, a member of the Methodist Church, had tried to bring her up right, and her father was always kind and indulgent toward her. She said "the devilment began to crop out" in her only after she enrolled in the public schools at Webb City. "I don't know why either," she concluded. "Nobody ever taught me any wrong. I'm not like other women, either, in blaming my downfall on any man."[53]

As May had predicted, she served only eighteen months of her two-year sentence. Apparently having followed through on her promise to "be a good girl," she was released from prison on December 22, 1894, under the three-fourths law. What happened to her after her discharge remains even more of a mystery than her exact origins.[54]

Chapter 3

CORA HUBBARD,
FEMALE BANK ROBBER

Twenty-year-old Cora Hubbard's story made headlines across America in the aftermath of her participation in the robbery of a bank at Pineville, Missouri, on August 17, 1897. One exaggerated newspaper report claimed Cora was the leader of the gang that pulled off the job and that she had served her apprenticeship in crime under the infamous Daltons "in some of the bloodiest expeditions ever organized in the West. How many men she...killed may never be known."[55]

While Cora's real story is less startling than the extravagant version told by sensationalist newspapermen, the truth is fascinating enough without embellishment. Born in Ohio to Samuel and Elizabeth Hubbard, Cora came to Missouri as an infant, and at the time of the 1880 census, she was living with her family in Callaway County. Between 1880 and 1885, the mother died, and the family moved to Kansas. Sometime after 1885, Samuel Hubbard, his daughter Cora and at least two or three of her siblings settled in Weir City in the southeast corner of the state. As a young woman, Cora lived in and around Weir, but according to the *Weir City Daily Sun*, she led "a nomadic, dissolute life." While still a teenager, she married Joe Russell, but the couple was divorced in May 1897. Most observers deemed Cora unattractive, but just a month or two after her divorce, she had already found herself a new husband, Bud Parker. She joined him at his farm near Nowata in Indian Territory.[56]

Also living on the farm were Cora's elder brother, William, and a young man named John Sheets. The twenty-three-year-old Sheets, like the

Hubbards, lived in Weir City or, in the words of the local paper, had been "a hanger-on" there for the past year or two and had developed a reputation as a loafer. Not long after Sheets and the Hubbards took up residence on the Parker farm, thirty-one-year-old Whit Tennyson drifted in. Claiming to have experience in the work of robbery, the smooth-talking Tennyson proposed holding up a bank. He soon had Sheets "in the notion of helping him out," and the rest of the destitute bunch at the Parker farm agreed to go along on the caper. The Bank of Pineville, Missouri, was targeted because Will Hubbard had previously lived there, and he drew a map of the place, giving the layout of the town and the location of the bank. When it came time to actually "do the work," though, as Sheets later recalled, Will Hubbard and Bud Parker backed out. Still eager to undertake the venture, Cora rode off in anger with Sheets and Tennyson, swearing that Parker was "a damn coward" and she wouldn't live with him.[57]

Cora and her sidekicks rode north from Indian Territory into Kansas. They stopped at Coffeyville, where Sheets bought a Winchester and a pistol and furnished Cora with men's clothing. Continuing on to Weir, the threesome called at the Hubbard home. Old Man Hubbard was startled to see Cora with her hair cut short, dressed in men's attire and in the company of two men he had never seen before. She introduced John Sheets as her latest husband. As Sam later explained, though, he looked upon his daughter as "a motherless girl" and couldn't bring himself to turn her away.[58]

After hanging around Weir for a couple days and stocking up on ammunition, the three would-be robbers rode toward southwest Missouri. They reached Pineville, almost seventy miles from Weir, on the evening of August 16 and camped on a hill just northeast of town. On the morning of Tuesday, the seventeenth, Tennyson and Sheets rode into town to reconnoiter the bank and, upon finding nothing to make them reconsider their plan, returned to camp to get Cora. The three then rode into town about nine o'clock and stopped at a vacant lot near the barn of a local resident named Hooper, just a block or so from the bank.[59]

Cora was left to guard the horses at the barn while Sheets and Tennyson started toward the bank on foot. Shortly after the two men left, Brit Hooper, whose father owned the barn, approached the building leading some horses. Initially mistaken for "a small young man or boy, part Indian," Cora presented her weapon and told the lad to stay right where he was. Brit "did just as he was told," but he apparently seemed a bit nervous to Cora, who, according to one newspaper report, coolly advised him that there was "no use to get excited" at a time like this.[60]

Meanwhile, Sheets and Tennyson approached the bank from a side street and came around the corner to find bank president A.V. Manning, cashier John W. Shields and county treasurer Marcus LaMance sitting out front. Presenting his weapon, Shields drove the bank officers inside, while Tennyson stayed outside to guard LaMance and keep a lookout for anybody else who might come along. Cursing and threatening the bankers, Sheets compelled Manning to hold a sack open while Shields, according to the *Pineville Herald*, "dumped in all the money in sight." The total take in currency and coins, including over $5 in pennies, was slightly less than $600.[61]

After securing the cash, Sheets forced the two bank officers back outside, and he and Tennyson marched them down the street "at a lively trot," keeping the bank officials in front of them to prevent anybody from firing at them. Back at the Hooper barn, Sheets, Tennyson and Cora quickly mounted up and rode off to the northeast, the same direction they had come from, with one of them firing a parting salute into the air as they galloped away.[62]

About a mile outside town, the three bandits met Floyd Shields, a son of the bank cashier, riding a mare named Birdie, and Tennyson commandeered the animal, leaving his horse in exchange. After traveling a short distance farther, the three robbers changed directions, circling around Pineville to head in a southwesterly direction.[63]

Meanwhile, word of the robbery was sent to Noel, which lay in the direction the gang was headed, and a posse went out on the afternoon of the seventeenth to lay in wait at a ford on Butler Creek, a couple miles south of town where the fugitives were expected to cross. A posse from Pineville joined them, and sure enough, Cora and her sidekicks rode right into the ambush about five o'clock that afternoon. The deputies opened fire, wounding both Sheets and Tennyson in several places, but one or more of the gang managed to return fire as Sheets and Cora wheeled their horses around and rode back up the gulch in the direction they had come, while Birdie bolted and ran in a different direction. As Cora and Sheets galloped away, Sheets's horse dropped dead from under him, having been wounded during the mêlée, and he mounted behind Cora as the two made their getaway. After riding double a short distance, they met a man on horseback, and Cora held him up at gunpoint, relieving him of his horse and helping her wounded companion mount the animal. The couple then kept west, changing horses one more time as they made for Kansas.[64]

The posse called off their chase after Sheets and Cora to turn their attention to the other bandit. They found Birdie, grazing with her saddle on but missing her bridle, about a mile from the scene of the fight, where

Tennyson had abandoned the animal. With darkness coming on, the pursuit was temporarily called off, but another posse caught up with Tennyson about six o'clock on Wednesday evening at an isolated cabin in Indian Territory twenty miles southwest of Southwest City. Tennyson surrendered without a fight, turning over his .44-caliber Winchester and .44-caliber pistol. The robber also had $121.50 and Birdie's bridle in his possession when captured. Tennyson at first refused to give his name, but he was taken back to Southwest City and recognized there because he had lived nearby several years earlier. He then revealed that the bank robber who was thought to be a boy was actually a woman named Cora Hubbard and that she and the third bandit were both from Weir City, Kansas. He also implicated Will Hubbard in the planning of the robbery. On Thursday, August 19, Tennyson was transported from Southwest City back to Pineville and from there to the Newton County jail in Neosho to await the action of a grand jury.[65]

Meanwhile, Sheets and Cora made their way to Parsons, Kansas, where they parted company. Against Sheets's advice, Cora took a train back to Weir on the morning of August 21, while Sheets hung around Parsons with plans to follow Cora in a few days so that the two of them could make their escape to Iowa together. Cora had scarcely reached Weir when a three-man posse headed by Cashier Shields, acting on the information provided by Tennyson, arrived in town about 11:00 a.m. and enlisted the cooperation of local law officers in tracking down the remaining fugitives. Under the guise of borrowing a tar kettle from Sam Hubbard, city marshal Jim Hatton went to the Hubbard residence to reconnoiter the place and learn whether Cora or any of the other principals in the robbery were present. He returned with information that Cora was indeed on the premises, but before she could be apprehended, Will Hubbard was spotted on the streets of Weir and taken into custody for his role in the holdup.[66]

After Will had been lodged in the local jail, three carriages loaded with lawmen drove to the Hubbard residence, and deputies surrounded the place. One of them tapped on the door with the muzzle of his rifle and leveled it at Cora when she answered the door. She raised her hands in surrender but "showed no signs of fear or emotion," according to the *Weir City Daily Sun*. Instead, she "acted more like a child at play putting up its hands before a toy pistol."[67]

Not allowed time to dress completely, Cora was hustled away from the Hubbard residence without socks and shoes and brought downtown. She briefly joined her brother at the local jail, but the pair were quickly whisked away by buggy to Asbury, Missouri, before they had a chance to demand

requisition papers. From Asbury, the brother and sister were put aboard a train, and they reached Joplin on the evening of the twenty-first. Describing Cora as "what looked like a man, arrayed in a woman's calico dress and barefooted," a *Joplin Daily Herald* reporter said the arrival of the Hubbard siblings caused "a tremendous excitement" in town.[68]

The captives were temporarily lodged at a hotel, and the reporter interviewed Cora in her room. A new pair of shoes and stockings were brought to Cora during the interview, and the newspaperman was taken aback when she put them on in his presence "without any special display of modesty on her part." After Cora admitted her role in the Pineville robbery, the reporter asked her whether she was frightened while she was standing guard. "Not a damned bit," she swore. "I could have held up the whole damned town." The *Herald* man claimed Cora had more nerve than any of the gang, and he said that she handled a pistol "like a veteran." He concluded his story with a physical description of the female bandit: "She is of medium height with black hair cropped like a boy's, is strongly built, has masculine features and looks more like a boy than a woman."[69]

After just a few hours' layover in Joplin, Cora and her brother were put aboard a train about midnight on the night of the twenty-first and taken to Neosho, where they were lodged in the Newton County jail for safekeeping to await the legal proceedings against them in neighboring McDonald County.[70]

Under a headline calling Cora "the second Belle Starr," the *Herald* story was astonishing enough in its own right but no more so than other newspaper stories that appeared in the wake of her arrest. Another local story claimed Cora's "daring deeds" rivaled those of Belle Starr and Kate Bender, the leading spirit of a Kansas family that slaughtered seven or eight people in the early 1870s. A story that ran in newspapers across the country claimed that, in the "running fight" that occurred after the robbery, "none were handier with a revolver" than Cora, who supposedly had her hat pierced in three places and her horse shot out from under her yet managed to escape unharmed.[71]

A few days after Cora's arrest, Marshal Hatton of Weir City became suspicious that part of the money taken from the Pineville bank might still be hidden at the Hubbard residence, and he and a deputy paid a visit on the evening of August 24 to instigate a search of the premises. They found $25 buried in the Hubbard garden in a hill of peppers before calling off the search on account of darkness. The next day, they returned and found another $141 buried in a hill of potatoes. Also found on the premises were the men's clothes Cora had worn and a rusty old .45-caliber Colt revolver

CORA HUBBARD, BANDIT

Leader of a Band of Southwestern Desperadoes.

CAN RIDE, SHOOT AND STEAL.

Served Her Apprenticeship With the Dalton Gang—Heroine of the Recent Bank Robbery at Pineville, Mo.—Captured After a Lively Skirmish.

A headline detailing Cora Hubbard's exploits published in the wake of her arrest. *From the Roanoke (VA) Times.*

with the name "Bob Dalton" carved on the handle in crude letters and seven notches filed on the trigger guard that were presumed to represent the number of men killed with the weapon. The *Weir City Daily Sun* reported that Cora had claimed at various times to have ridden with the Dalton gang in previous years but that the statement had always been passed off as "idle boast." Now, however, the discovery of the rusty old pistol seemed to add credence to her claim. Thus, another sensational element was added to her marvelous tale. The story that ran in newspapers across the country took the embellishment for a fact and declared that while riding with the Daltons, Cora "was chased all over the plains of Oklahoma and Indian Territory by United States marshals." Many observers remained skeptical, though. One newspaper report, for instance, suggested that Bob Dalton's name had been carved on the pistol by someone other than Dalton and that there was "nothing to justify Cora's claim that it had ever belonged to Bob Dalton."[72]

Right: Cora Hubbard poses in the men's clothing she wore during the robbery. *Courtesy McDonald County Library.*

Below: Bank robbers Cora Hubbard, Whit Tennyson and John Sheets. *Courtesy McDonald County Library.*

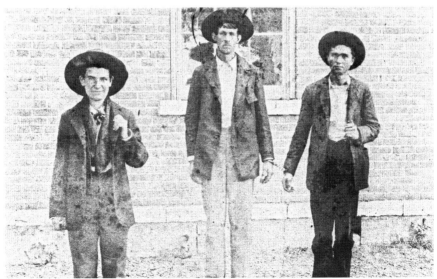

On August 26, the day after discovery of the rusty pistol, Cashier Shields and McDonald County sheriff Richard Jarrett arrived in Weir to assist Hatton in recovering the rest of the bank money, and the three men repaired to the Hubbard home about noon. They had just arrived and were still discussing how to proceed when Sheets unsuspectingly drove up in a buggy. Shields recognized the newcomer, according to the *Weir City Daily Sun*, as "the man who had transacted business at the McDonald County bank on a large scale," and Sheets was promptly arrested. His six-shooter was confiscated, and another ninety-one dollars of the missing bank loot was recovered.[73]

Sam Hubbard was also taken into custody because of his reluctant cooperation with authorities in locating the stolen money, and he and Sheets were promptly transported to Missouri, along with the clothes Cora wore during the holdup and other evidence confiscated from the Hubbard residence. On August 28 in Pineville, Cora donned the clothes and had her picture taken while she and the others implicated in the bank robbery were in town for their preliminary hearings. During the proceedings, Old Man Hubbard and his son were released without charges, while Tennyson, Sheets and Cora were bound over to await the action of a grand jury and returned to Neosho for safekeeping.[74]

The trio was brought back to Pineville on January 9, 1898. Formally indicted for bank robbery on the eleventh, all three pled guilty. Cora and Sheets were sentenced to twelve years apiece in the state penitentiary, while Tennyson received a ten-year sentence.[75]

In late December 1904, Cora, having served almost seven years of her twelve-year sentence, had it commuted by the Missouri governor because of her good behavior. Considered a "model prisoner," she had learned to sew while incarcerated and planned to pursue employment as a seamstress upon her release. However, what happened to her after her release on January 1, 1905, has not been traced.[76]

ZEO ZOE WILKINS,
GOLD DIGGER EXTRAORDINAIRE

In her thirst for riches, Zeo Zoe Wilkins had already left a trail of victims who'd fallen prey to her feminine wiles before she met and latched on to wealthy Missouri banker Thomas W. Cunningham in 1912 in Claremore, Oklahoma. But it was not until the elderly Cunningham unexpectedly sold his bank five years later and friends in his hometown of Joplin began to question his lengthy and unexplained absence from home that the beautiful thirty-one-year-old osteopath was thrust into the limelight as a temptress and gold digger extraordinaire. After Cunningham filed for divorce in 1917 and the sensation surrounding the scandal gradually subsided, Zeo went back to relative anonymity, but she continued her conniving ways, charming another series of unfortunate men out of their money. It was not until the remarkable Dr. Z was mysteriously murdered in Kansas City in 1924, shortly after she'd retained the services of attorney Jesse James Jr., son of the infamous outlaw, that her name was once again plastered in newspaper headlines across the country. The reckless life she had led finally caught up with her.[77]

Born in October 1885, the youngest of eleven children in a poor Ohio farm family, Zeo left home as a preteen to live with elder siblings in Cleveland. Determined to become rich and make a name for herself, she lied about her age and got herself admitted, alongside an elder sister, to the American School of Osteopathy in Kirksville, Missouri, in the summer of 1903 when she was just seventeen. Although she had dropped out of high school, she was a bright girl and made decent grades, but what she really had her sights set on was meeting and marrying a wealthy man. By some accounts, she

wed her first husband, a young man she met at the school, just weeks after arriving in Kirksville.[78]

What is known for sure is that she married thirty-six-year-old Charles Garring, a recent graduate of the Kirksville institution, in July 1904, when she was exactly half his age. Dr. Garring set up a practice at Durant in Indian Territory (now Oklahoma), while Zeo returned to school to complete her degree. Upon graduation in 1905, she joined her husband's practice in Durant, but their marriage was on rocky ground almost from the beginning, allegedly because of her overly friendly relations with some of her male patients. Then, one night in late 1905 or early 1906, Zeo shot and wounded her husband as he returned home. She told police that she mistook him for an intruder, but Dr. Garring claimed in the divorce suit he filed shortly afterward that she had tried to kill him for his insurance money.[79]

After her split with Dr. Garring, Zeo hung out her shingle in the booming oil town of Sapulpa, Indian Territory, where she became the mistress of banker B.B. Burnett, and he was accused of embezzling funds from the bank, supposedly for her use. Moving on to her next target, Dr. Wilkins set up shop in Tulsa. The "brunette of dazzling beauty," as the local newspapers called her, had many male friends in Tulsa and reportedly entered into another short-lived marriage, this time with a twenty-eight-year-old furniture dealer named Grover Burcham.[80]

About 1911, Zeo moved thirty miles east of Tulsa to the mineral water town of Claremore, where a young man named Leonard Smith fell into her clutches. He reportedly lavished her with gifts, and she repaid him with counterfeit love, finally driving him to suicide.[81]

In 1912, Thomas Cunningham, a sixty-eight-year-old banker from Joplin, Missouri, came to Claremore to take the cure at Zeo's medical clinic. The wealthy widower suffered from locomotor ataxia, a condition often associated with venereal disease that causes victims to walk with jerky motions and otherwise lose control of their body movements and that is sometimes amenable to osteopathic manipulation. The elderly Cunningham, whose worth was estimated from $1 to $2 million, was also showing signs of senility. He was an easy mark for the beautiful twenty-six-year-old doctor, and she could hardly wait to get her hands on him—and his money.[82]

Not long after Zeo met Cunningham, she used her sugar daddy's money to buy herself a house in Kansas City and set up a new practice. Meanwhile, Cunningham maintained his home in Joplin, but the two exchanged visits regularly during the next few years and secretly wed in Kansas City in November 1914. Shortly after the marriage, Zeo moved to a summer home

Cunningham maintained for her in Colorado Springs. He occasionally visited her there, and neighbors assumed he was her father. None of Cunningham's friends in Joplin suspected anything out of the ordinary until he left home in early October 1916, announcing he was going to Colorado Springs for his health, and did not return in a timely fashion.[83]

There was a good reason Tom stayed gone. Zeo had her claws in him and didn't mean to let go until she had strengthened her claim on his riches. Either the couple's Missouri marriage license had been forged, as Cunningham's allies later claimed, or else the old man simply had no recollection of the ceremony. Whatever the reason, Zeo felt it necessary to marry her husband a second time in order to solidify her legal position, and on December 5, 1916, she and Cunningham exchanged wedding vows in Kiowa, Colorado. Almost immediately after the Colorado wedding, she coaxed the gullible old man into signing all his stock in the Cunningham National Bank over to her. She then promptly traveled to Denver, where she met Amos Gipson, president of a rival Joplin bank, and sold the stock for over $300,000.[84]

Meanwhile, Zeo was carrying on with her latest lover, playboy Albert Marksheffel, a Colorado Springs automobile dealer who also served as Zeo's personal chauffeur. Marksheffel was helping Zeo scheme to get her husband's money. Perhaps to avoid arousing undue suspicion that she was spending too much of the money herself, Zeo occasionally induced Cunningham to write checks to Marksheffel or to her maid instead of directly to her.[85]

On January 14, 1917, a front-page headline in a Joplin newspaper announced the sale of Cunningham's bank by a young wife that no one in Joplin even knew he had. The sensational news caused a stir among the old man's Joplin friends, who worried that he had been taken for all his money, but no one was more upset than seventy-one-year-old Mrs. Tabitha Taylor, Cunningham's live-in housekeeper. She claimed also to be his common-law wife, and the very next day after the local newspaper story appeared, she filed a divorce suit seeking a portion of his estate. Citing the unknown woman with whom Cunningham had been living in Colorado as the cause for her suit, Mrs. Taylor claimed she and Cunningham had lived together as man and wife since 1899 and that she had been a dutiful and faithful wife.[86]

Interviewed by a newspaper correspondent in Colorado Springs, Tom Cunningham denied that he was ever married to Tabitha Taylor or lived with her as man and wife. He said he and Zeo would continue to make their home in Colorado Springs but that they planned to travel a good deal. Zeo explained to the same newspaperman that she and Cunningham had been married over two years, that they were very happy together and that

his money had been in her name since shortly after the marriage. Zeo's neighbors told the correspondent that Zeo always had a lot of money and had bought a new car a few months ago, while Cunningham had seldom been seen until a few weeks ago, when he had arrived for an extended stay.[87]

After Mrs. Taylor's suit was filed and the news of Zeo's marriage to a wealthy man who was old enough to be her grandfather became public, stories about the scandal appeared in newspapers across the country. One such story, picked up by the wire services and reprinted in a number of papers, appeared under the headline "'Eternal Triangle' Bared When Housekeeper, 71, Sues Aged Millionaire After His Marriage to Kansas City Beauty," and it pictured the three principals connected by a triangle.[88]

Near the end of January, Zeo and her husband left Colorado Springs, and Zeo turned up in Kansas City, where she took a room at the ritzy Muehlebach Hotel. Saying she had convinced Cunningham not to settle Mrs. Taylor's suit out of court, as he was initially inclined to do in order to avoid publicity, Zeo retained lawyer Frank P. Walsh to represent her interests in the suit. Meanwhile, her elderly husband could not be located, and his friends and business associates grew concerned for his welfare.[89]

On February 2, Cunningham was located at the Blackstone Hotel in Chicago, but those attending the old man, including Walsh, would not admit newspapermen seeking an audience with the banker. As soon as the reporters left, Cunningham was spirited away to a rooming house in a poor part of town, while his young wife checked into the swanky Hotel Sherman. On February 5, Cunningham was again located in Chicago, and an old friend from Joplin persuaded him to return to Missouri. The next day, when Cunningham and an entourage that included Walsh and one of Zeo's brothers reached Kansas City, they were met at Union Station by law officers from Jasper County with a warrant for Cunningham to appear at the county court in Carthage for an inquiry into his sanity. Meanwhile, Tabitha Taylor added an alienation suit against Zeo Zoe Wilkins, seeking $250,000, to the litigation against Cunningham that she had already filed.[90]

After Cunningham reached Carthage on February 6 and was taken to the sheriff's home, he was visited there by a number of friends, including Tabitha Taylor. She threw her arms around the banker and declared that she was "happy as a lark" to see him, and Cunningham seemed pleased to see her as well. Asked about his young wife, Tom explained that she had remained in Chicago because she was ill.[91]

Interviewed back in Chicago in her fancy suite at the Hotel Sherman, Zeo discussed the "weird tangle of love and finance that might have supplied a

plot for Zola or Balzac." As she yawned luxuriously and "stretched out beneath the snowy sheets," Zeo laughed off Tabitha Taylor's attempt to claim part of Cunningham's fortune as the futile, pathetic effort of an old woman. Calling Mrs. Taylor a fool, "the comely Mrs. Cunningham," as the reporter described her, declared that the old woman would "never get a cent." Zeo also scoffed at the notion that she herself was only after Cunningham's money and that she had been trying to hide him from his friends. "Her dark eyes sparkling, she sat up in bed with a kittenish movement," said the newspaperman, "swept her heavy hair back from her brow with her bare arm and exclaimed, 'That certainly is the most ridiculous thing yet.'"[92]

"It is mirth provoking, is it not," she continued, "to think of that grandmotherly old woman, who ought to be at home darning stockings for her grandchildren, chasing after my husband and trying to get his money?" Snuggling back into her downy pillow, Zeo concluded, "She's too old to think of love. Love is not for such as she. Love is only for youth and beauty."[93]

A day or two later, Mrs. Taylor again visited Cunningham at Carthage and invited him to come "home" for Sunday dinner, to his apartment above the Cunningham Bank building on Joplin's Main Street. The old banker seemed pleased by the prospect, and local authorities agreed to furlough him long enough for him to make the trip. Despite his apparent affection for Mrs. Taylor, Cunningham declared that he did not regret the sale of his bank by his wife, and he vowed to fight the charge that he was mentally irresponsible. Zeo had every right to sell the bank, he said, because it belonged to her.[94]

Meanwhile, newsmen in Chicago again called on Zeo in her luxurious suite at the Sherman to get her reaction to the latest developments involving her husband. One reporter observed:

Like Madame Du Barry, who received her courtiers in bed that she might more proprietly enchant them with glimpses of her bare arm, Mrs. Zeo Zoe Wilkins Cunningham…receives the fortunate newspaper men who are detailed to interview her. Without troubling herself to arise from her four-poster, and like her erratic but also beautiful predecessor in the affections of aged men who sometimes yield to the soothing of love that is young, the pretty Zeo Zoe generously and frequently displays an arm that is rosy with the tints of youthful femininity.

Informed that her husband had seemingly reconciled with Tabitha Taylor, Zeo retorted merrily, "Bosh, rubbish, likewise pish and tish."[95]

On February 10, Cunningham traveled to Joplin, where he consulted with his attorneys, greeted old friends and was briefly received by Mrs. Taylor at his old residence above the bank. On the same day, reporters uncovered evidence of the secret wedding between Cunningham and Zeo Zoe Wilkins in Kansas City in 1914 but were unable to verify the second marriage in Colorado. Informed that Cunningham and young Zeo Zoe were indeed married, Mrs. Taylor refused to believe it.[96]

On February 13, after a consultation among the lawyers involved in Cunningham's case, the old banker was granted his freedom through a writ of habeas corpus and the insanity hearing against him canceled in exchange for his agreeing to let the court appoint Tillie Muller Ade, a longtime cashier at his bank, as the trustee of his estate. Shortly afterward, Cunningham moved back into his old quarters with Mrs. Taylor, and on February 20, it was announced that he planned to stay in Joplin and that he had been reelected to a three-year term as a commissioner on the area's special road district.[97]

A few days later, reporters learned that Cunningham and Mrs. Ade had filed suit against Zeo Zoe Wilkins Cunningham and Amos Gipson, alleging that Zeo's sale of the Cunningham Bank to Gipson had been transacted without Cunningham's knowledge or approval, and the plaintiffs sought to recover the money Zeo had received from Gipson. On February 24, Cunningham also filed for divorce from Zeo. The suit alleged Zeo had not only defrauded Cunningham financially but had also humiliated him by stating publicly that she only married him for his money. At the same time, Mrs. Taylor announced that she intended to drop her divorce suit against Cunningham.[98]

Zeo left Chicago and returned to Colorado Springs near the end of February. Reporters interviewed her there on March 1, but she refused to discuss the financial and divorce suits filed against her by Cunningham. During the first week of March, Cunningham took out an ad in the *Joplin Globe* seeking to clarify misleading reports that had been published about his suit against his wife and Amos Gipson. Cunningham wanted it known that he had authorized his wife to sell his bank stock and that Gipson had acted in good faith but that Zeo had misappropriated the funds and used them for her own benefit after the transaction was completed. Tom said he only sued Gipson to restrain him from paying Zeo any remaining disbursements that might be due under terms of the contract.[99]

On March 8, Zeo broke her silence regarding the suits Cunningham had brought against her, refusing at first to believe that any such suits had actually been filed. She added, however, that Cunningham had given her the bank stock and that any proceeds she had gotten from the sale of the stock

were rightfully hers. She also declared, "If Mr. Cunningham doesn't want to come here to me, all well and good. He is old enough to know what he wants to do."[100]

America's looming entry into World War I dominated the headlines for the next few weeks, but Tom Cunningham and Zeo Wilkins were back in the news in early April when Cunningham was granted a divorce from his wife. Financial terms of the decree allowed Zeo to keep all but $6,000 of the funds she had received from the sale of the Cunningham Bank, meaning she walked away from the marriage over $300,000 richer than she entered it. However, she was required to deed back to Cunningham his old bank building and certain other real estate and financial holdings.[101]

Less than a month after her divorce from Cunningham, Zeo married Albert Marksheffel on May 7, 1917, in Colorado. She and her new husband honeymooned in Kansas City, staying at the Muehlebach Hotel, where they ran up a bill of $5,000 on their $100-a-night room, extravagant dinners and generous tips. Zeo also briefly rendezvoused with her old flame from Oklahoma, B.B. Burnett, from whom she purchased a $5,000 oil lease that soon yielded her almost $200,000. Back in Colorado Springs, she earned a reputation as "one of the most lavish spenders…in a city of lavish spenders." During her marriage to Marksheffel, Zeo gave up her practice of osteopathy to lead a life of luxury and debauchery, hosting wild parties and eventually developing a drinking problem. She and Albert fought regularly, and the couple split in about 1919, although their divorce was not finalized until a couple years later.[102]

After her breakup with Marksheffel, Zeo returned to Kansas City, where she met wealthy saloonkeeper John McNamara at the Paseo Hotel in August 1919 and launched an affair with him. In February 1920, McNamara's wife, Nellie, filed an alienation of affection suit against Zeo, seeking $50,000 in damages. Nellie's lawyers, who had also represented Tom Cunningham at one point, claimed that Zeo had gone with McNamara to various places inside and outside Missouri, had made love to him and had, "through wiles and machinations," caused him to lose affection for his wife and practically abandon her. The suit lingered in the courts, and in 1921, Nellie added an amended complaint. It charged that Zeo had represented herself as McNamara's wife on numerous occasions and told people at other times that she and McNamara were going to get married as soon as he could get a divorce, had escorted him to elegant parties, had taken rides with him throughout Jackson County and traveled with him through the summer resorts of Colorado in her expensive limousine and had "applied her art

Zeo Zoe Wilkins and Albert Marksheffel's wedding photo. *Courtesy Pikes Peak Library District.*

and profession as an osteopath" to give him treatments and massages. The following year, however, Nellie withdrew her suit when Zeo bid adieu to her latest lover and a chastened McNamara promised to "cease his affections" for the vampish doctor.[103]

After Zeo's divorce from Marksheffel became final in 1921, she sold her house in Colorado and moved permanently to Kansas City. In 1922, she

returned to Kirksville to take an advanced course in a new osteopathic treatment called the Abrams method, but her life continued to spiral out of control once she returned to Kansas City. Increasingly addicted to alcohol and drugs and facing litigation involving debts she owed, she absconded to Texas and stayed several months with her sister Gertrude, who ran a sanitarium in Fort Worth. Alarmed by Zeo's reckless lifestyle and her alcohol and drug abuse, Gertrude had her sister committed to the sanitarium and, when Zeo responded by trying to kill herself, had her taken into protective custody by the Fort Worth police. The authorities could only hold Zeo so long, however, and she soon went back to Kansas City.[104]

Zeo rented a house near downtown Kansas City at 2425 Park Avenue. She practiced osteopathy out of her home and later shared space with John C. Klepinger, doctor of osteopathy, at his Thirty-first Street office in exchange for training him in the use of the Abrams machine, an electronic device that could supposedly diagnose and treat syphilis and other serious diseases, but by 1923, it had already been largely debunked by the scientific and medical communities. Although Zeo catered to wealthy patients, she herself seemed always strapped for cash because of her extravagant lifestyle. She employed domestic workers she often couldn't pay, gave wild parties and, according to several reports, stayed drunk much of the time. Although not the stunning beauty she had been years earlier, Zeo still drew men like moths to a flame, and she entertained a whole series of lovers at her house on Park in an upstairs room she called her "trysting place."[105]

In the fall of 1923, Zeo took sick, but when the doctors who attended her attributed her illness to too much alcohol, she resisted the diagnosis and, instead of seeking further medical treatment, sent instead for her brother Charlie, the only person she felt could help her. When Charlie Wilkins arrived from Seattle, however, he joined the doctors' efforts to get her off booze, and she flew into a rage when he deliberately broke one of the last bottles of whiskey in the house. Under Charlie's tough therapy, Zeo's health gradually improved, but she and her brother continued their heated arguments, with Charlie sometimes resorting to violence to enforce his strict demands. The pair fought not just about Zeo's drinking but also about her spendthrift ways and about her numerous lovers, whom Charlie particularly resented. During one fiery and protracted quarrel, Charlie had Zeo's beloved pet bulldog, which had attacked him on a couple occasions, put to death and tried to blame it on Ben Tarpley, one of her lovers.[106]

In early 1924, Charlie Wilkins invited an asthmatic friend named Charles Smith to come to Kansas City and take Zeo's Abrams treatments for his

ailment. Smith arrived on February 11, but after just a few days, Charlie became concerned that Zeo and her new patient were becoming a little too intimate. He ordered Smith to leave, and he and Zeo got into another quarrel. When Ben Tarpley showed up, Zeo ordered both Smith and her brother from her house. They left but came back later, and Smith, who had decided to leave town, demanded that Zeo give him back the money he had paid for his treatments because they hadn't helped his asthma. She refused, and the two got into an argument, with Charlie taking his friend's side in the quarrel. When Zeo again tried to make the two men leave, Charlie pushed her and she fell. Frightened and upset by the incident, Zeo called several of her friends and lovers and told them she was afraid of her brother and Charlie Smith, that they had threatened to kill her, that Charlie had beat her up and that he had also killed her dog. One of the men she called was Gus West, who referred her to Kansas City attorney Jesse James Jr., son of the infamous outlaw.[107]

Zeo first met with James at his law office on February 28, 1924. She sought protection, claiming her life was in danger, and she also enlisted the attorney to extract payment for a debt she said her ex-husband, Al Marksheffel, still owed her. Zeo and James met several other times, both at his office and at her house, over the next couple of weeks. James believed Zeo was delusional, but at some point in early March, he apparently did contact Marksheffel about the supposed debt, which, in fact, had already been discharged.

On March 12, Zeo called Gertrude and told her sister that someone was out to get her. But Gertrude, like James, felt Zeo was imagining things and that she was not actually in physical danger. On March 13, Zeo's landlady, Gertrude Palmer, called at the Park Avenue house to dun Zeo for rent money that was long overdue, but Zeo put her off, claiming her finances were tied up in litigation in Colorado. Later the same day, Charlie visited his sister and, according to his later testimony, overheard her telling an unidentified man, who was examining Zeo's Abrams device, that she desperately needed money and would sell him an interest in the machine for $100.[108]

On Friday, March 14, Zeo asked her friend Eva Grundy to come over, and Eva arrived about noon and found Zeo in the throes of paranoia. When Eva started to fix a sandwich, Zeo, fearing someone was trying to poison her, cautioned her friend to make sure the paper covering the loaf of bread was not broken. Later, she told Eva that four people were trying to kill her and that she had only twenty-four to forty-eight hours to live. She mentioned a Kansas City doctor and then later spoke of how her brother Charlie mistreated her and said she didn't trust her lawyer, Jesse James

Jr. Appearing very nervous, Zeo spoke at length about arrangements she was trying to make to open a sanitarium, which she thought would be her financial salvation and might also somehow save her life. She offered Eva a lucrative position at the sanitarium once the arrangements were made and then asked for a loan as a token of her friend's confidence in the proposal. Eva wrote her a check for fifty dollars, and as she was leaving, Zeo told her she was having an important meeting with someone the next day at 3:00 p.m. Zeo wanted Eva to return at that time.[109]

On Saturday morning, Zeo went to Eva's bank to cash the check. Eva met her there, but Zeo left quickly, saying she had to get back home. Shortly before noon, Dr. Holly G. Haworth, a fellow osteopath, met Zeo at her house to discuss going into a partnership together, and they agreed to meet again on Sunday. About noon, Mrs. Palmer called again about the overdue rent, and Zeo told her she would have the money after she conferred with certain people later the same day. Eva never appeared for the 3:00 p.m. meeting, and neither did anyone else. Ben Tarpley called at Zeo's house about 3:30 p.m. While he was there, a black man named Dillard Davies, one of Zeo's hired hands, stopped by with a veterinarian to whom he owed a dollar and asked Zeo to pay the bill out of past wages she owed him, which she did. Ben Tarpley left Zeo's house shortly before 5:00 p.m. Except for her killer, he was the last person to see her alive.[110]

A number of people—including Tarpley, Eva Grundy and Mrs. Palmer—called at Zeo's house during the day on Sunday but left when no one answered their knocks on the door. That evening, Dr. Haworth arrived to keep his appointment with Zeo, but he, too, got no answer to his knock. Aroused by noises coming from the alley behind Zeo's house that he considered suspicious, Haworth called police. The two patrolmen who responded found a broken basement window in Zeo's house, but they left without further investigation after pounding on the front door and concluding that the house was deserted.[111]

On Monday, March 17, Mrs. Palmer called at Zeo's house twice more without rousing anyone. On Tuesday, she came back and noticed a window on the side of the house partly open even though the weather was chilly and snowy. She asked Isidor Cortez, a thirteen-year-old boy who lived next door, to investigate the odd circumstance, and he crawled up a ladder to look in the window. Scurrying back down, he told Mrs. Palmer there was someone lying on the floor. Two Kansas City patrolmen responded to the landlady's call and found Zeo Wilkins dead and the room reeking from the smell of decay. Bloodstains and other signs of violence were everywhere. A

Zeo Zoe Wilkins's death certificate. *Missouri State Archives.*

bloody knife was found on the rug, chairs had been turned over and broken and shelves and drawers had been rifled through. A coroner's investigation concluded that the deceased had been stabbed to death on Saturday evening. Multiple wounds and abrasions on the body, along with the disordered house, indicated that the deceased had put up a struggle before succumbing. Ben Tarpley, Dillard Davies and Zeo's brother Charlie were detained as suspects in the aftermath of the killing, but no one was immediately charged. Jesse James Jr. was among the many witnesses interviewed.[112]

Word of Dr. Zeo Zoe Wilkins's murder hit the newspapers on Wednesday, March 19, making headlines across the country. In addition to giving the circumstances of the crime, most accounts also reiterated the details of Zeo's scandalous life. The story was given especially prominent play in cities

where she had lived or otherwise left her mark. The *Joplin Globe*, for instance, captioned its story of the incident with the headline "Divorced Wife of Tom Cunningham Slain." Beneath a subhead that read "Murdered in Kansas City" ran a large photo of Zeo taken when she was married to Cunningham.[113]

Investigators concluded, after thoroughly examining Zeo's house, that the crime had not been random. The murderer had ransacked the place looking for something, apparently valuables such as jewelry, but testimony conflicted as to whether Zeo actually had a large quantity of valuables in her home. The search of the house also turned up a number of financial papers showing that Zeo, since squandering her Cunningham fortune, had been living well above her means and owed debts to various people. One prominent theory of the crime was that Zeo's killer might have been a jealous lover. As the *Kansas City Post* observed, "No enchantress of history ever seemed to have aroused the infatuation of more men admirers" than Zeo Wilkins. Detectives also theorized that Zeo's murderer could have been a jealous woman whose husband or boyfriend Zeo had stolen, a common thief who was strictly after her valuables or one of the persons she had been afraid of, perhaps someone to whom she owed money.[114]

On Sunday, March 23, thousands of curious people streamed by Zeo's house on Park Avenue, eager to get a glimpse of the last residence of the murdered siren. Her funeral was held on March 25 with only a few of her friends and relatives in attendance, and she was buried at Forest Hill Cemetery in Kansas City.[115]

The day before Zeo's funeral, Tarpley, Davies and Charlie Wilkins were arraigned on first-degree murder charges. However, the charges against Tarpley and Wilkins were dismissed in April, and those against Davies were dropped several months later. No one else was ever charged in the crime. Even during the hours and days immediately after Zeo's body was discovered, some observers considered the investigation into her murder almost hopeless because of the many suspects and possible motives. As more and more details of her personal life emerged during the aftermath of her death, investigators became even less hopeful that her killer would ever be found. As a Kansas City newspaper said just days after her murder, "So many stories of intrigue and adventuring have been woven around Dr. Wilkins's name in the last eight years, police are left groping in a maze of innumerable hypothetical clews." Almost one hundred years later, the mystery has still never been solved.[116]

SERIAL KILLER BERTHA GIFFORD

Twenty-four-year-old Henry Graham must have felt as if he'd won the blue ribbon at the local fair when he latched onto Bertha Williams and married her in Hillsboro, Missouri, in December 1894. Said to be one of the prettiest girls in Jefferson County, the dark-haired, twenty-two-year-old Bertha settled down with Henry at Morse Mill, where they'd both grown up. A year and a half later, the couple had a baby girl, Lila. Located on Big River about six miles northwest of Hillsboro, Morse Mill was a resort community featuring the Morse Mill Hotel, which catered to the St. Louis elite and other tourists. Bertha went to work there, but after a few years, her marriage to Henry Graham ran into trouble. Sometime around 1905, according to later rumors, Henry got involved with another woman, and Bertha started spending time with a local boy named Eugene Gifford, who was almost ten years younger than she was. Still a beautiful woman in her early thirties, Bertha seemed to have a strange power over Gene, and he broke off his engagement to another girl. Henry and Bertha started arguing all the time, but before the marital drama could reach a climax, Henry took sick and died of what was thought to be pneumonia. Nobody thought much about it, and Bertha collected insurance on her husband's death. Then, in 1907, after a respectable mourning period, she and Gene got married and soon moved away from Morse Mill, settling in the Catawissa area of neighboring Franklin County.[117]

Gene Gifford rented a place from Phil Brinley in the Big Bend community (so called because of the nearby bend in the Meramec River) north of

Catawissa and took up farming. Most people thought Gene and his wife were friendly enough folks. Bertha fed the hired hands and other visitors, and she became known in the community for her excellent cooking. She was always ready to help, too, when someone took sick, and she soon earned a reputation in the neighborhood as a country nurse who people could turn to during trying times. "Anyone got sick, she was right there," recalled a neighbor many years later. "She'd run over with a satchel. She always wore a white apron when she came to call. Later on I think she started to wear a regular nurse's outfit. She was always meticulously clean."[118]

In January 1912, Gene's widowed mother, Emily Gifford, came to stay with her son and his wife, and she fell ill shortly thereafter. Catawissa physician W.H. Hemker was called to the Gifford home on the twenty-third, and the next day, the fifty-four-year-old woman died. Dr. Hemker listed aortic regurgitation as the cause of death. It was nothing out of the ordinary; sometimes old women died.[119]

In early May 1913, James "Jimmie" Gifford, Gene's twelve-year-old kid brother, also fell sick and died at the Gifford home. Dr. Hemker, who was again the attending physician, listed "strangulation due to an accumulation of mucous and an inability to expectorate," which he said was a complication of whooping cough, as the cause of death. As was the case with the boy's mother, nobody thought much about Jimmie Gifford's death. Back in those days, with no vaccinations and no antibiotics available such as we have today, it wasn't unusual for children to die from illnesses like whooping cough. Near the time of Jimmie's death, Gene and Bertha moved from the Brinley farm to the neighboring Dehn place. About a year later, Bertha gave birth to a baby boy. She and Gene named the child James in honor of Gene's deceased brother.[120]

On February 10, 1915, little Bennett Stuhlfelder, fifteen-month-old son of George and Frances Stuhlfelder, came down with pneumonia. Dr. D.E. Williams from nearby Pacific attended the boy for the first five days and then left him in the care of the family and Nurse Gifford. Dr. Williams was called back to the Stuhlfelder home on February 26 when the child took a turn for the worse, but little Bennett died later the same day of what Dr. Williams listed as bronchopneumonia. The infant was interred at the nearby Rock Church Cemetery.[121]

About noon on February 20, 1917, Gene Gifford saw Sherman Pounds, a cousin and near neighbor of his, staggering around drunk on the road outside the Gifford home and brought the forty-nine-year-old widower inside. Bertha nursed him with her potions throughout the day, but he only got worse. Sherman's daughters were summoned from their house just

over the hill, and that evening, Dr. H.A. Booth was called to the Gifford home from Pacific. By the time he got there, though, Sherman Pounds was unconscious, and he died shortly thereafter. Booth listed "acute alcoholism" as the cause, and nobody thought much about it. After all, everybody knew, as Gene Gifford later said, that Sherman drank "quite a bit" and would "have a spell every once in a while."[122]

On November 17, 1917, Bertha Gifford made one of her periodic trips to Pacific and, as she was wont to do, purchased arsenic at Power's Pharmacy to kill the rats, she said, that were bothering her chickens. Two days later, sixty-six-year-old James Lewis Ogle, who had worked off and on as a hired hand for Gene Gifford for several years, fell ill at the Gifford home. Dr. Hemker was called to attend the patient. The next day, November 20, Ogle was dead. Hemker said he died of pernicious malaria of the gastro-enteric type.[123]

On or about February 20, 1921, two-year-old Margaret Stuhlfelder, another child of George and Frances Stuhlfelder, took sick with pneumonia just as their infant son, Bennett, had done six years earlier. Mrs. Stuhlfelder later recalled the circumstances of Margaret's illness. "We called Dr. Hemker, and he prescribed for her. Mrs. Gifford, as usual, came over to nurse the sick baby. She told me, 'The baby looks to me as if she's awfully sick; I don't think she'll get well.' At the end of the second day, Margaret began to vomit, and after another three days she died." The exact date of death was February 28, and Dr. Hemker listed the cause as bronchopneumonia.[124]

Marguerite Pounds had remained close to the Giffords even after her father, Sherman, had died in their home in 1917. In 1922, Marguerite's boyfriend, Fletcher Rosen, went to work on the Gifford farm, and on August 11, 1922, the "Big Bend News," a local news and gossip column in the *Pacific Transcript*, reported that Marguerite had spent most of the previous Sunday as a guest in the Gifford home. Three weeks later, the same column said that Bertha Gifford and Marguerite Pounds had recently made a shopping trip to the city together. On December 26, Marguerite and her three-year-old daughter, Beulah, visited the Gifford home and ended up spending the night at the insistence of their hosts. The next morning, the twenty-year-old unwed mother fixed breakfast for her daughter and then left to run some errands, leaving Beulah in the care of Mrs. Gifford. When Marguerite returned a couple hours later, Beulah was complaining of stomach pains. The girl had never been sick before, so a doctor was not called immediately. When the child started vomiting, Dr. Hemker was summoned, but little Beulah died just minutes after he arrived. The doctor listed "acute gastritis" as the cause of death.[125]

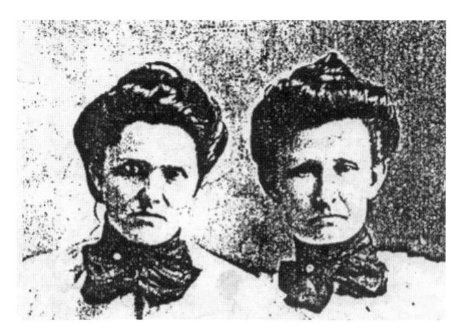

Bertha Gifford, right, with her sister, circa 1920. *Courtesy Washington Historical Museum.*

This time, though, not everybody kept quiet. Marguerite's sister, Ida, thought it suspicious that both her father and her niece had died in the Gifford home after experiencing severe stomach pains, and she asked about a postmortem examination. Bertha grew indignant, saying that she "would have no such thing in her home," and Ida exchanged some heated words with the older woman before backing off when Bertha told her she would have to bear the expense of such a procedure herself. Bertha was so upset by the confrontation that she didn't show up when Beulah was, according to the *Pacific Transcript*, "laid to rest in the new cemetery after a touching service by Rev. Jens" a day or two later. It was said to be the first time since Bertha had moved to the area that she'd missed the funeral of someone from the Bend.[126]

After the death of Beulah Pounds, Fletcher Rosen quit his job working on the Gifford farm, married Marguerite Pounds and moved to Catawissa. Although he and Marguerite later came back to the Bend, they were never on good terms with the Giffords again. Other people started whispering as well, but still no one would openly accuse Bertha Gifford of any wrongdoing.[127]

On or about March 6, 1923, two years after the death of Margaret Stuhlfelder, yet another Stuhlfelder child fell seriously ill. Seven-year-old Irene Stuhlfelder, according to her mother, had always been bothered with

worms, so it wasn't surprising when she came down with a stomach ailment. The Stuhlfelders summoned Dr. Hemker, and he prescribed some stomach powder that seemed to help. Irene, said her mother, "seemed to be getting along very well when Mrs. Gifford came by. Mrs. Gifford nursed her, and she started to vomit. She was sick nine days when she died." Perhaps so, but Dr. Hemker treated her for only five. Irene died on March 10 from what the doctor said was "acute hepatic abscess due to intestinal parasites." Within the space of eight years, three children of George and Frances Stuhlfelder had died in their home after being treated by Bertha Gifford, but as Frances later recalled, she and her husband did not think there was anything strange about it at the time. "Everybody in this part of the country," she explained, "knows Mrs. Gifford has a wide reputation as a nurse."[128]

Sometime after Beulah Pounds died in their home in late 1922, the Giffords moved again, taking up residence this time on the Nicholson farm near Catawissa. On August 8, 1925, George Schamel came with his sons, Lloyd and Elmer, to stay at the Giffords' latest home. Schamel had recently lost his wife, and Gene and Bertha agreed to take the family in and give George a job doing chores on the farm. Seven-year-old Lloyd was ill when the Schamels arrived on a Saturday evening, and Dr. Hemker was summoned to the Gifford home the next day. The doctor left some medicine for Bertha to administer, but by Tuesday, August 11, little Lloyd was in a coffin. Dr. Hemker attributed the death to an "acute unknown disease" with "acute gastritis" as a contributory cause.[129]

After Lloyd's death, the Giffords moved again, accompanied by George Schamel and his remaining son, to the 180-acre Freie farm between Catawissa and Pacific. On about September 18, 1925, six-year-old Elmer took sick, and Dr. Hemker came on the nineteenth to the two-story white house on the Bend Road and left some medicine. He was called back on the twenty-first when Elmer took a turn for the worse. By early the next morning, the boy was dead. His suspicions aroused by the fact that both Schamel boys had exhibited the same symptoms and had died at the home of Gene and Bertha Gifford within the space of six weeks, Dr. Hemker recommended an autopsy, but George Schamel wouldn't agree to it. Even after the doctor told Schamel that all expenses for the autopsy would be paid, the father still did not want one performed. Hemker considered ordering an autopsy anyway but decided he didn't want to take the responsibility as long as the father opposed it. So the doctor wrote "acute unknown disease" and "acute gastritis" on Elmer's death certificate just as he had on Lloyd's. Two days later, the little boy was laid beside his brother at nearby Bethlehem Cemetery.[130]

George Schamel later disputed the notion that Dr. Hemker had pressed him on the issue of an autopsy, but he admitted that he didn't suspect anything at the time. "I liked the Giffords fine," he explained. "I thought it was just my bad luck." However, other folks did begin to suspect something. As one neighbor recalled many years later, "The truth is that there wasn't real suspicion for the longest time. Not until the Schamel boys died." A few people wrote letters to county prosecutor Frank Jenny suggesting that he investigate a number of mysterious deaths that had occurred in the Bend community, but most of the letters were vague and anonymous. One woman signed her name, but she didn't provide the names of victims or other specifics and did not reply to Jenny's letter asking for more information. So the prosecutor declined to order an inquiry. None of Bertha's other neighbors did anything about their suspicions except gossip.[131]

In early February 1926, seventy-two-year-old Bertha "Birdie" Unnerstall got sick, and Bertha Gifford came over to tend to her. Dr. Hemker was called, too, and he arrived on the sixth. Three days later, though, Birdie was dead from what Hemker listed as "chronic myocarditis" (inflammation of the heart wall leading to heart failure). Not long after Birdie's death, her son, Gus, got into a dispute with Gene Gifford over some equipment Gus had left at Gifford's place. Later on, Gus came over to the Gifford place to talk about the situation again, and Bertha reportedly ran him off with a butcher knife, screaming and cursing him as she did so. Gus Unnerstall had Bertha placed under a peace bond (a writ similar to a restraining order that requires a citizen to keep the peace).[132]

In addition to her apparent violent streak, Bertha Gifford was also reputed to be a sneak thief who habitually stole small articles, many of them of no use to her, from stores in both Catawissa and Pacific. Referring to Ben Scheve's general store in Catawissa, one neighbor recalled years later, "Bertha Gifford used to go in there and take a whole bolt of goods out and put them on her wagon. Just steal them." Scheve never pressed charges, though, because Gene always covered for her.[133]

On the evening of May 15, 1927, forty-nine-year-old Ed Brinley drove his automobile into the front yard of the Gifford place and got out. Gene Gifford came out to greet him and invited him inside. Brinley, who had been drinking and seemed upset, came inside briefly but then went back outside and insisted on staying there. He lay down on the floor surrounding the cistern, but Gifford finally got him back inside and put him to bed. Gene left for St. Louis early the next day, while Bertha made a trip into Pacific and purchased more arsenic for the pesky rats on her place. When Brinley got up, he said he felt somewhat

better and asked for something to eat (although it's not clear whether this happened before or after Bertha's trip to Pacific). Mrs. Gifford fixed him two ham sandwiches, and he became ill shortly after he ate them. Mary Brinley, Ed's mother, came over and insisted that Dr. Hemker be summoned, and he arrived from Catawissa about 4:00 p.m. Bertha told the doctor that Brinley had been drinking and that she was afraid he might die because of it. Brinley, on the other hand, mentioned having eaten the sandwiches, and after examining the patient with a stethoscope, Hemker felt sure the man had something wrong with him besides just an upset stomach. He left, however, instructing Mrs. Gifford to call him if the patient got worse.[134]

Around 8:30 p.m., Dr. Hemker was called back to the Gifford home, and he found that Brinley was vomiting and was much worse. Mindful of the other recent deaths that had occurred at the Gifford home under mysterious circumstances, Hemker thought it best to bring in another physician, and Dr. A.L. McNay was called from Pacific. By the time McNay arrived, however, Brinley was unconscious, and he died an hour later. Gene Gifford, who had returned from St. Louis, thought Brinley had simply "got hold of some bad liquor," but Hemker didn't think the patient had died from the effects of poisoning by fuel oil, such as might be found in moonshine. Instead, Hemker suspected foul play, or so he said later, but he and McNay could not agree on the cause of death. Not wanting to lay himself open to a libel suit in case he was wrong, as he later explained, Hemker finally wrote "acute unknown disease" and "acute gastritis" on the death certificate.[135]

Ed's estranged wife, Ludelphia Brinley, arrived the next day, May 17, and at some point during the day, she and Bertha Gifford left the house, where Ed's body was laid out, and were engaged in conversation outside. Bertha, according to Ludelphia's later testimony, said that she knew Mary Brinley would be upset by her son's death but that the mother was really better off because now "she wouldn't have to worry about him."[136]

Mary Brinley had hardly enough money to pay her son's doctor bill, so she asked Gene Gifford to approach Ed's uncle Phil, the man from whom Gifford had rented when he first came to the Bend, about paying for the funeral service. Phil Brinley refused, however, saying he'd already spent enough money on his nephew over the years. Gene then volunteered to pay for the embalming and burial with the stipulation that the Brinley family could pay him back a little at a time. Ed Brinley was laid to rest the next day, May 17, in the Brush Creek Cemetery near Gray Summit. According to the *St. Louis Times*, "The Giffords, being good friends of the Brinleys, attended the service."[137]

Ludelphia Brinley, the widow of Ed Brinley, testified against Bertha Gifford. *Courtesy Washington Historical Museum.*

The newspaper added, though, that after the death of Ed Brinley, "the tongues of Catawissa again began to wag." People started calling the Gifford home on the Bend Road "the house of mystery" or "the death house," and some pressed for an autopsy. The talk upset Bertha Gifford, who felt, according to the *Times*, that she was being unduly accused and that all the gossip was "not the proper recompense" for the charitable work she was trying to do. A few days after Ed Brinley died, Bertha went to see Dr. Hemker and showed him the bottle from which Brinley had "done his drinking." When Hemker said he

The so-called house of mystery, or death house, on the Bend Road as it appears today. Although only Elmer Schamel and Ed Brinley died here, this "eerie dwelling," according to the *St. Louis Post Dispatch*, "inherited the cumulative effect of the other deaths." *Photo by the author.*

wasn't interested, Bertha protested that she only wanted him to see "what kind of stuff Ed had been drinking."[138]

Bertha also spoke to Mary Brinley in the days after her son's death. Aware of the talk about an autopsy, Bertha said during casual conversation, according to Mary's later statement, "Don't you let them dig up Ed's body." Mary's immediate reaction to the admonition is not known, but at some point, Ludelphia Brinley, and perhaps other members of the Brinley family, belatedly sought an inquest into Ed's death. Although the effort was to no avail, the pressure on Prosecutor Jenny to take some sort of action gradually mounted. More letters recommending an investigation trickled into his office, and the *St. Louis Times* sent a reporter to Franklin County to do a story on the mysterious deaths. Finally, Jenny called a grand jury to look into the case at the November 1927 term of court, six months after Brinley's death.[139]

During the inquiry, Bertha Gifford threatened libel suits against any of her neighbors who testified against her and against any newspaper that published damning accusations. Her threats reportedly "scared off the investigation," and the grand jury failed to indict her.[140]

The people around Catawissa, however, continued to talk and kept up the pressure on the prosecutor. At least partly in response to the gossip,

CAPIAS

THE STATE OF MISSOURI

STATE OF MISSOURI, } ss:
County of Franklin,

TO THE SHERIFF OF FRANKLIN COUNTY—GREETING:

WE Command You to take *Bertha Gifford* if he be found in your County, and *her* safely keep, so that you have *her* body before the Judge of our Circuit Court, at the Court House in Union, within and for said County of Franklin, on the *3rd* Monday in *November* next, then and there, before our said Judge to answer an *Indictment* preferred against *her* by the *Grand Jury* of Franklin County, State of Missouri, aforesaid, for *murder in the first Degree—*

Whereof he stands charged. And this you shall in no wise omit. And have you then and there this Writ.

Given under my hand and the seal of said Court. Done at office in Union, in the County aforesaid, on this *23* day of *August* 19 *25*

illegible signature

Circuit Clerk.

A warrant for Bertha's arrest. *Courtesy Washington Historical Museum.*

no doubt, the Giffords moved away in March 1928, settling in the Eureka area of neighboring St. Louis County. Afterward, even more people came forward who were willing to testify, and Frank Jenny summoned another grand jury for the August term of the Franklin County Circuit Court. In addition to considering the statements of the new witnesses, the jury also heard testimony that Bertha Gifford had purchased arsenic at two different Pacific drugstores going back to 1911. Her signatures on the store ledgers showed that, in three cases, she had bought arsenic just a few hours or a few days before someone had died at her home. This time, the jurors came back with an indictment charging Bertha Gifford with first-degree murder in the deaths of Elmer Schamel and Ed Brinley.[141]

Through special arrangement, police chief Andrew McDonnell of Webster Groves, located a few miles west of St. Louis, was asked to make the arrest. He went out to the Giffords' rural Eureka home on Friday, August 24, to take her into custody. Bertha took time to powder her face and then put on a hat before following McDonnell to his car and getting in. Without informing Bertha she was under arrest for murder, McDonnell drove her to

Clayton, neighboring Webster Groves, to await the arrival of Sheriff Arthur Gorg of Franklin County so that she could be turned over to the proper authorities. Questioning Bertha about the deaths that had occurred in her home, McDonnell elicited a statement from her admitting that she had given arsenic to Lloyd Schamel, Elmer Schamel and Ed Brinley by lacing Dr. Hemker's medicine with it. She said that, in all three cases, the patients were suffering from severe stomach pains and that she gave them a small amount of arsenic to "quiet their pains." The plump but still rather attractive woman explained confidentially that she sometimes took arsenic herself to keep her skin looking young.[142]

When Sheriff Gorg arrived the next morning, McDonnell had a statement prepared of what Bertha had told him the previous day, and she signed it in the presence of both lawmen and a Webster Groves police judge, acknowledging that she did so of her own free will. According to McDonnell, Gorg specifically told her that the statement might be used against her, and she indicated she understood. "I don't want to live," she supposedly cried. "I want to tell the truth. I told you about giving some of them arsenic; maybe I gave some others arsenic, too."[143]

Accompanied by McDonnell, Gorg took Bertha back to the Franklin County seat in Union on Saturday. Upon their arrival, she reportedly corroborated her statement in the presence of the two lawmen, Prosecutor Jenny and a local newspaperman. She kept saying, however, that the arsenic didn't kill Brinley and the two boys, that she had taken lots of it herself and that she wished she had some right now. Gorg locked her up without bond in the jail on the third floor of the courthouse. Unlike McDonnell and Jenny, Sheriff Gorg had a certain sympathy for Bertha, believing she "attributed some mystical healing power to arsenic and gave it to her patients without sinister motive." The other two men did not share Gorg's opinion but were unable to say just what her motive might be.[144]

Although Bertha was cooperative when she was initially arrested, by Saturday evening, she was "not in a conversational mood," having apparently "suffered a realization of her status before the law," according to the *Union Republican Tribune*. She refused to eat, and by Monday, the twenty-seventh, she was on the verge of collapse but declined to see a doctor. When a St. Louis reporter visited her that day, she berated Chief McDonnell for having allowed her confession to be published in newspapers the previous day, and she sobbed that she would deny everything. When questioned about other people who had died while under her care, she covered her face with a blanket and merely repeated what she had admitted before, that she had

given arsenic to Ed Brinley and the Schamel boys to quiet their pains. Later that evening, Bertha finally ate some ice cream.[145]

Mrs. Gifford was arraigned the next day, August 28, and an indictment for the murder of Lloyd Schamel was added to the two indictments originally issued by the grand jury. Bertha's lawyers, whom her husband had hired to defend her, entered a plea of not guilty on all charges. Her trial was set for the third Monday in November. Meanwhile, an investigation into a number of other deaths that had occurred while the deceased person had been under the care of Bertha Gifford was begun. Altogether, she was implicated in at least seventeen deaths, going all the way back to her first husband.[146]

A week later, a report in the local newspaper said Bertha was a "good prisoner" who was now eating regularly and seemed to be content with her lot. However, she still refused to talk to reporters or anyone else other than her husband or Sheriff Gorg and still declined to have her picture taken.[147]

Prosecutor Jenny sought the exhumation of the bodies of Ed Brinley and the Schamel boys, and state health commissioner James Stewart, after visiting with Jenny in Union on September 6, returned to Jefferson City to request such an order. After the three bodies were dug up on September 18, Dr. Stewart announced that the initial postmortems strongly pointed toward poison but that the vital organs would have to be taken to St. Louis for chemical analysis in order to be sure. On October 9, it was announced that tests done in a St. Louis laboratory had found quantities of arsenic in the vital organs of all three bodies sufficient to cause death. A Franklin County coroner's jury met the same day in Pacific and concluded that the two Schamel boys "came to their death from poison administered at the hands of Bertha Gifford." Because only meager evidence was produced in the Brinley case, the jury found that Ed had died as the result of "homicide at the hands of parties unknown." Frank Jenny explained that he meant to try Bertha Gifford for the murder of Ed Brinley first and that he didn't want to tip his hand to the defendant's lawyers by producing all of his evidence now. Gene Gifford attended the coroner's jury in Pacific, as he did all of his wife's legal proceedings. After hearing the verdicts, he walked expressionless from the room.[148]

Bertha went to trial for the murder of Ed Brinley before Judge Ransom A. Breuer in the Franklin County Circuit Court on Monday, November 19, with Frank Jenny prosecuting the case and attorneys James Booth and W.L. Cole representing the defendant. Interest in the case was nationwide, and newspaper reporters and other spectators filled the courtroom. Selection of the twelve male jurors took up much of the first day. Then, over the next

On Trial for Poison Death.

—By a Post-Dispatch Staff Photographer

MRS. BERTHA GIFFORD

PHOTOGRAPHED today at Union, Mo., where she is on trial for the murder of Edward P. Brinley.

A newspaper photo of Bertha Gifford during her trial. *From the* St. Louis Post-Dispatch.

day and a half, Jenny presented the case for the state. Among his witnesses were Dr. Hemker, the lead doctors involved in the exhumation of the three bodies, one of the Pacific druggists who had sold arsenic to Bertha, Chief McDonnell and several people who had knowledge of the circumstances surrounding the death of Ed Brinley, including his mother and his estranged wife. Near the end of the second day, Bertha's lawyers tried to get her signed statement to McConnell and his testimony about the statement thrown out on the grounds that it was not meant as a confession to murder but simply a statement of certain facts surrounding the deaths of Brinley and the Schamel boys. Judge Breuer ruled that the statement itself could not be admitted as evidence but that McConnell's testimony about what Bertha had said could be.[149]

Failing in their attempt to exclude the contents of Bertha's statement, her attorneys resorted to an insanity defense when it came time for them to present their case on the third day of the trial. Bertha's husband, Gene, was called as a witness to testify that Bertha was nervous and excitable. Four other acquaintances of the defendant gave similar testimony. Several Franklin County doctors were called to the stand and asked what they would conclude if they knew the defendant was nervous and restless, had administered arsenic to patients for years in the hope of helping them, had stated that she herself had long taken arsenic for her looks and her heart, had tended to the sick for years without reward, had always been kind to those she treated and had no motive for killing her patients. They all agreed that she would be insane, and the defense rested its case. The state called two alienists (i.e., psychiatrists) from St. Louis as rebuttal witnesses, but the St. Louis doctors agreed with the local physicians and offered the opinion that Bertha was suffering from the mental disease of paranoia (which today we would probably call schizophrenia). After hearing all the testimony, the jurors deliberated for three hours and came back with a verdict late on the evening of November 21 that Bertha was not guilty by reason of insanity.[150]

Judge Breuer ordered that Bertha be confined to a mental institution for the duration of her insanity, which a local newspaper speculated could easily be the rest of her natural life. Bertha was escorted to the Farmington State Hospital (then often called the insane asylum) on December 19, 1928. Later, she was, ironically enough, assigned the job of being a cook at the hospital. The local newspaper's prediction that Bertha's incarceration might last the rest of her life proved true, as she died at the Farmington facility on August 20, 1951.[151]

BERTHA GIFFORD, CHARGED WITH MURDER DECLARED INSANE IN CIRCUIT COURT HERE

Jury in Franklin County Circuit Court Here Reached Verdict
After Three-Day Trial Finding De-
fendant Insane.

A headline announcing the verdict in Bertha's case. *From the* Union Republican Tribune.

So did Bertha Gifford kill seventeen people or more? Almost certainly not. At the time of the first grand jury investigation, she was suspected in the deaths of only five people, and she was later charged in the deaths of only three. Not until she was indicted during the second grand jury in those three cases did the other twelve cases involving people who had died while under her care come under scrutiny. Apparently Bertha was considered a suspect in every single case in which someone died while under her care, including those of her own family members, but it defies logic and statistical odds to think that every patient who died while under her care did so at her hand. Sometimes, especially before modern medicine, people died regardless of the care they received, which, of course, was why Bertha was not suspected for the longest time. Also, Missouri death certificates show that some of the people who died while under Bertha's care did so from causes that do not suggest arsenic poisoning. The most likely scenario, then, is that while Bertha did not kill seventeen people, as she was suspected of doing, she very well might have killed more than three. In fact, she virtually admitted as much.

Whether Bertha killed three or seventeen people, the next question to consider is whether she killed them deliberately. If we assume, for the sake of argument, that she did not kill them intentionally, we are left with two options. The obvious possibility is that she sincerely thought the arsenic she fed them would help them. Arsenic in low doses was, indeed, used medicinally during the 1920s, but it seems unfathomable, given the amount of arsenic found in the exhumed bodies, that Bertha could not have known that she was giving her patients more arsenic than was safe. Even if she didn't know this at first, she would have realized after one or two of them died, unless she was delusional, that her "cure" might be contributing to the deaths and would have discontinued the regimen before administering it to her next patient. Bertha's great-granddaughter, S. Kay Murphy, has suggested a second possibility—that Bertha gave her patients arsenic with

the intention of making them sick but only so that she could then make them well again and redeem herself as a self-sacrificing nurse in the eyes of her friends and neighbors. This scenario, however, only makes Bertha look worse than the first possibility. In fact, it makes her almost as villainous as if she killed her patients in cold blood. Only a crazy person would continue to deliberately make her patients sick after one or more of them had died from such induced sickness just so she could try to make herself look good.

So that leads us to the final question. Was Bertha Gifford insane? Almost certainly. Either she was a homicidal serial killer who deliberately administered fatal doses of arsenic to her patients and then went right on being friends with her deceased patients' families; was so out of touch with reality that she failed to make the connection between her administration of arsenic and the "acute gastritis," accompanied by vomiting, from which several of her patients died; or was intentionally endangering her patients' lives just to inflate her own sense of self-worth. In any of the three cases, Bertha Gifford was insane.

Irene McCann

From Good Girl to Bad Woman

After eighteen-year-old Irene Scott ran away from her northeast Alabama home in the fall of 1929, she, at first, wrote letters to her mother, Velma Richardson, promising she would soon return. In her last letter, dated December 1929, Irene told her mom she was working as a waitress in Dallas and that she would come home as soon as she got the money to travel. For the next year, Mrs. Richardson heard nothing more from Irene. She grew increasingly worried to the point that she finally concluded in despair that her daughter must be dead. Irene wasn't dead, but her mother was right to be worried.[152]

Irene's father, George Scott, a deputy sheriff in DeKalb County, was killed by moonshiners in 1919 when Irene was just eight years old. Velma remarried shortly thereafter. Despite the turmoil in her early life, Irene was a "good girl" growing up, according to her mother, and even taught a Sunday school class at the local Baptist church. One day, though, she just decided to "pick up and run off."[153]

From Dallas, instead of returning home, Irene traveled across the country, working as a dancer, entertainer and waitress in various places, including Florida, Chicago and New Orleans. In the latter city, she and two male companions were arrested on suspicion in May 1930 for lurking around a movie theater on Canal Street, and Irene spent a short time in the city jail.[154]

In the fall of 1930, Irene's wanderings brought her to southwest Missouri, where she landed a job as a waitress at a Springfield restaurant and boardinghouse. She met a seventeen-year-old Joplin boy named Albert

McCann there, and just a few weeks later, on November 7, the couple got married in Columbus, Kansas. (One dubious report claimed Irene had been married and had two children prior to wedding McCann, but the story seems exaggerated at best.)[155]

According to Irene's later testimony, she "learned to love" Albert because he behaved like a perfect gentleman during their courtship, but just a week after their marriage, he began to drink heavily and to curse and beat her and even attempted to shoot her during a drunken rage. She stayed with him, she claimed, only out of fear.[156]

In early November, Irene and her husband fell in with another couple, Paul Hindman and Peggy Moss. The two men committed a couple of robberies in the Joplin area, with the women waiting in the car each time. Then, on November 20, 1930, the foursome drove to Kansas City, where the two men killed seventy-one-year-old drugstore owner R.S. Pinegar when he resisted their holdup attempt.[157]

On the morning of Sunday, December 14, Irene and Albert drove to the Jasper County seat at Carthage because Albert wanted to try to break a friend of his named Raymond Jackson out of jail. He sent Irene into the jail first to scout the place out under the pretext of seeing another friend, Bill Daggett, but the jailer, E.O. Bray, told her Daggett was not there. After she reported the news to McCann, he went back to the jail with her and again asked to see Daggett. When Bray told him that Daggett was no longer in the jail and turned to look at the record book showing his release date, McCann grabbed the officer's revolver from its holster and ordered Bray to put up his hands. When Bray resisted, McCann shot him and then, during a struggle for the gun, shot him two more times, killing him almost instantly. A fourth shot wounded McCann. He later claimed that Irene fired the fourth shot, aiming for Bray but wounding him accidentally instead, but Bray's teenaged son, the only witness to the mêlée, confirmed Irene's story that she did not fire a shot.[158]

Irene grabbed Bray's keys and handed them to her husband, who dashed up the steps to where the cells were. Realizing he was in the wrong part of the building, he came running back down and told Irene, "Let's go. We can't do it." He and his wife raced out of the building, and in going through the gate leading from the jail yard, Irene stumbled and broke a heel off one of her shoes.[159]

After making their escape, the couple drove to Oklahoma and stopped in Chelsea to buy bandages for Albert's wound. When Irene went into a drugstore to make the purchase, Tom Dean, the city marshal, happened to be present, and he noticed that the young woman was missing a heel from one

resign.

HELD IN JAILER'S DEATH

Associated Press Photo

Police say Albert McCann (right), 19, and his young bride, Billie Lee McCann, confessed they entered the county jail at Carthage, Mo., in an attempted jail delivery and killed E. O. Bray, jailer. The woman, police said, blamed liquor, asserting she and her husband sought to release a friend now under a penitentiary sentence.

A newspaper photo of Albert and Irene McCann after their capture. *From the* Altoona (PA) Tribune.

of her shoes. The next day, he read a newspaper account of Bray's murder that mentioned the woman losing a heel from her shoe. He called officers in Jasper County, who sent him photos of the suspects, and Dean positively identified them as the couple he'd seen at the drugstore. Two weeks later, when the pair again appeared on the streets of Chelsea, he arrested them without incident, and they were brought back on December 31 to Jasper County, where Irene gave her name as Billie Lee at first.[160]

Albert's case was severed from his wife's, and at his trial in April 1931, he was convicted of first-degree murder and sentenced to hang in July. Irene, who had previously said she felt "sorry for the boy," was reportedly grief-stricken upon hearing the news. Albert's case was appealed to the Missouri Supreme Court, and his execution was stayed pending the appeal.[161]

While expressing sympathy for her husband, Irene seemed to take little interest in her own plight until her trial came around in May. Facing a first-degree murder charge and a possible death penalty, just as Albert did, she testified in her own defense, saying that she had never fired a gun in her life and that she'd only gone along with her husband's crimes because she was afraid not to. The jury found her guilty of second-degree murder and sentenced her to ten years in prison. Irene received the verdict with a smile. "I was lucky," she said. "I think that under the circumstances the jury was kind to me, and I thank them."[162]

Irene was transferred to Jefferson City in late May and housed at the women's prison farm not far from the main penitentiary. In the wee hours of the morning on November 10, 1931, Irene escaped from a hospital at the prison farm and climbed over a high wire fence surrounding the facility. She left behind two notes apologizing for the trouble she had caused the warden

When a Woman Loves!

IRENE McCANN

Irene McCann took a chance of being shot by penitentiary guards in her effort to do something for her husband.

ALBERT McCANN

A newspaper sketch depicting Irene McCann's 1931 escape, along with photos of her and her husband. *From the* Kittanning (PA) Simpson's Leader Times.

and the prison matrons and explaining that she was escaping so she could get evidence that would help her husband. Irene, whom one of the matrons called "a bad woman," hid out in a barn for about twenty-four hours before being recaptured the next day walking along the road not far from the prison.[163]

Albert McCann was granted a new trial and a change of venue shortly after Irene's recapture. At his second trial in Springfield in May 1932, Irene was brought to court from Jefferson City to testify. Changing her story, she claimed that she did indeed fire the shot that wounded her husband. Whether her testimony helped Albert is speculation, but he got off with a lighter sentence this time—fifty years in prison as opposed to the death penalty.[164]

On December 13, 1932, Irene McCann made another dash for freedom from the prison farm when she and Edna Murray, the so-called Kissing Bandit, sawed their way out of a cell building that was designed for some of

IRENE M'CANN IN ESCAPE WITH 'KISSING BANDIT'

Notorious Inmates of Women's Prison farm Saw Way Out

A newspaper headline announcing Irene McCann's 1932 escape with Edna Murray, the Kissing Bandit. *From the* Sedalia Democrat.

the more unruly prisoners. After a little over a year on the lam, Irene finally turned herself in at Chicago in January 1934, saying, "I'm tired of it. I want to go back to prison and finish my term."[165]

She was taken back to Jefferson City but didn't have to stay long. Suffering from a serious illness, Irene was paroled in January 1936 to the custody of her mother, and she died shortly afterward.[166]

"SUICIDE SAL"

The Story of Bonnie Parker

Born in October 1910 in Rowena, Texas, Bonnie Parker moved to a Dallas suburb with her mother and two siblings after her father died in 1915. Bonnie was a good student in school and liked to write poetry, but she grew up poor and got married when she was just sixteen to Roy Thornton, a schoolmate who had spent time in an Oklahoma reform school. Thornton drifted in and out of her life during the next couple years, and he got sent to prison for robbery in early 1929. In February 1930, Bonnie met twenty-year-old Clyde Barrow for the first time while she was staying at the home of a neighbor in Dallas. Despite his youth, Clyde was already a veteran criminal, but Bonnie fell for the brash young man almost instantly. By the time she and Clyde first landed in Missouri two and a half years later, she had aided and abetted in several of Clyde's crimes and had been drawn inextricably into his gang.[167]

On Halloween night in 1932, Bonnie and Clyde drove to Missouri from Texas and reunited with two of Clyde's sidekicks, Hollis Hale and Frank Hardy, in Carthage, where the gang rented tourist cabins to use as their base of operations. The three men committed several robberies and thefts in the area during November before deciding to hold up the Farmers' and Miners' Bank in nearby Oronogo. Bonnie did not participate in actual robberies, but Clyde sent her into Oronogo on or about November 29 to scout out the place and bring back intelligence pertaining to the bank's layout and operating procedure.[168]

Late in the morning on November 30, Clyde and the other two men drove into Oronogo in a Chevrolet sedan, stolen earlier in the day in

The Oronogo bank building held up by Bonnie and Clyde in 1932, as it appears today. *Photo by the author.*

Carthage, while Bonnie waited in a getaway car, a Ford V-8, about a mile and a quarter west of Oronogo. Clyde got into a gun battle with the bank cashier during the robbery, and the three men made their escape through a hail of bullets from citizens who armed themselves upon hearing the commotion inside the bank. Reuniting with Bonnie outside town, they abandoned the Chevy sedan and piled into the Ford V-8 to complete their getaway.[169]

During the investigation that followed, two local men reported that they had seen a young woman about 10:15 a.m. in a Ford V-8 coupe parked where the abandoned Chevy was later found. She was wearing a blue dress, a red hat and a black jacket, they said, and was "nervously moving about in her car" as they passed her.[170]

After the bandits got back to the cabins, Hale and Hardy absconded with more than their share of the Oronogo cash and never came back. Bonnie and Clyde returned to Texas a short time later and hooked up with W.D. Jones, a sixteen-year-old boy with a criminal record whom Clyde had known for about ten years. Clyde and W.D., with Bonnie as an accomplice, pulled off a string of crimes in Texas, including two murders, before heading north and arriving once again in Missouri in early 1933.[171]

About 6:00 p.m. on January 26, the three desperadoes were prowling the streets around the Shrine Mosque in downtown Springfield in a Ford V-8, with Bonnie sitting in the front seat between Clyde and W.D., when motorcycle cop Tom Persell spotted them and grew suspicious. Persell followed the Ford and, as it started north across the Benton Avenue viaduct, pulled up beside it to order the driver to halt.[172]

Not wanting to stop in a place with limited avenues of escape, Clyde hollered that he didn't have any brakes, and he kept going until he reached the end of the viaduct, where he pulled on to Pine Street and eased to a halt. By the time Persell pulled up beside the Ford again, Bonnie had climbed into the back seat, and the cop saw her holding something in her hand but didn't realize until later it was .45 army automatic pistol. When Persell dismounted his motorcycle, Clyde stepped out to greet him with a sawed-off shotgun and ordered him to throw up his hands. After Persell complied, Clyde yanked the cop's pistol out of its holster, tossed it to W.D. Jones and ordered the policeman into the car beside Jones. Then Clyde hopped into the vehicle and took the wheel.[173]

After forcing Persell to pilot him through the streets of Springfield, Clyde drove east on Route 66 before telling Bonnie to look at a map. He then turned back toward Springfield, drove about a mile down the road and stopped. Commanding Persell to get in the back seat, the gangsters covered him with a blanket, and Bonnie held a gun on him while Clyde drove to the nearest service station and filled up with gas.[174]

Later, Clyde asked Persell whether there was a back road they could take to Joplin, and Persell told him there was, piloting the gang north out of Springfield toward Buffalo. At Crystal Cave, Clyde turned on to the Pleasant Hope road and headed west, going cross-country toward Golden City at fifty miles an hour over the muddy back roads. During the trip, Bonnie continually checked the road map to see which highway the gang was on or near.[175]

Telling his story to a newspaperman the next day, Persell recalled that the driver (i.e., Clyde) was the only one of the three gangsters who talked at first and that he was "quite profane." Later, though, W.D. and Bonnie became more talkative, and the cop remembered that "the girl…was as profane as her companions." Persell also complained that she and Jones starting mooching cigarettes off him after they'd finishing smoking theirs and that the girl "simply ate fags." He described Bonnie as red-haired and freckled and "not the least bit beautiful." She wore a dark coat and "turban-like hat on the side of her head," and Persell guessed her weight at about

110 pounds. He said the driver called the girl "Hon" or "Babe" and that the other fellow (i.e., Jones) called her "Sis."[176]

When the gang came out on a north–south highway west of Golden City (present-day I-49/U.S. 71), Clyde seemed to know where he was and no longer needed Persell to guide him. Dodging from one country road to another, he made his way toward Webb City. Along the way, he asked Bonnie, "Hon, do you think there are any cars we can get at Webb City?" When she answered in the affirmative, he struck out on another country road and came out in a residential district of Webb City, but the gang was unable to locate a suitable car to steal. Clyde then drove to Oronogo, where he joked with Bonnie and W.D. about the gun battle with the bank teller he'd had there a couple months earlier. Clyde next drove to the Roanoke neighborhood of Joplin, looking for a car to steal. W.D. got out and tried several cars, but before he could get any of them started, Bonnie saw someone looking out the window of a nearby house and advised Clyde to scram before the police came. The gang finally let Persell out unharmed north of Joplin near Carl Junction. The cop made his way into Joplin and, by the next day, was back in Springfield to tell the story of his ordeal, although he did not learn the identity of his captors until sometime later.[177]

After the Persell caper, Bonnie, Clyde and W.D. returned to Texas and reunited with Clyde's brother Buck, who had just been pardoned by the governor and released from prison. Clyde convinced Buck and his wife, Blanche, to go back with the gang to Missouri, where the five of them could rent an apartment at Joplin and have a relaxing family holiday. In late March, the gang headed north from Dallas in separate cars. Buck and Blanche were in the 1929 Marmon sedan Buck had bought upon his release from prison, and Bonnie, Clyde and W.D. were in the gang's latest stolen vehicle.[178]

On April 1, Buck, Blanche and Bonnie rented an apartment above a garage at 3347½ Oak Ridge Drive in South Joplin, with Buck giving his name as Callahan. The main house faced Oak Ridge, but the garage apartment faced Thirty-fourth Street, just a block and a half west of Main Street. The gang picked the location on purpose to allow for a quick getaway in case one was needed. Clyde parked his stolen Ford V-8 sedan in the garage below the apartment, sharing space with neighbor Harold Hill, who occupied the main house, while Buck rented garage space from another neighbor to keep his car.[179]

For the next several days, the gang lived a life of relative luxury. Bonnie and Blanche made trips to the local five-and-dime store to purchase costume jewelry, glassware and other knickknacks, and the gang also bought

The Joplin garage apartment where the 1933 shootout took place, as it appears today. *Photo by the author.*

linens, blankets and pillows to fix up the minimally furnished apartment. They even paid a watchman one dollar a night to guard their apartment and automobiles. Bonnie occasionally helped Blanche with the cooking, but mostly, she spent her spare time writing poetry or otherwise amusing herself. At night, the gang stayed up late playing cards, and they slept late in the mornings. On April 7, beer sales became legal for the first time since Prohibition, and Clyde, Buck, W.D. and Bonnie started buying and drinking a case of beer each night.[180]

After a week or so, the gang started running low on money, and Clyde, with W.D. and Buck alternating as his sidekick, began pulling off nighttime robberies in the area. Neighbors, however, soon grew suspicious of the unusual comings and goings in the garage apartment. They noticed that the occupants periodically switched license plates on their vehicles, kept the shades on their windows drawn at all times and mainly kept to themselves (although Bonnie did befriend a little girl named Beth). By the time W.D. stole a Ford roadster from Miami, Oklahoma, on April 12 and brought it back to the apartment in Joplin, the gang was already under police surveillance. Clyde convinced Harold Hill to let him keep the roadster in the garage with the gang's other Ford, no doubt arousing more suspicion.[181]

Later that evening, Bonnie and Clyde had a furious argument about the Ford roadster. Bonnie thought it was stupid to bring another stolen automobile to the apartment when they were trying to lie low, but Clyde didn't like having his decisions challenged. The quarrel turned violent, and Clyde knocked Bonnie across the room. According to Blanche's recollection, however, the feisty Bonnie "got up and went back for more." Later, the couple made up, as they always did.[182]

Although beer had been legalized, Prohibition was still in effect for hard liquor, and authorities suspected that the gang holed up in the garage apartment were bootleggers. On April 13, they decided to act. Armed with a liquor search warrant, five lawmen descended on the apartment about four o'clock that afternoon. Turning west off Main Street and approaching along Thirty-fourth Street, state troopers George B. Kahler and Walter E. Grammer led the way in one vehicle, while Joplin policemen Tom DeGraff and Harry McGinnis and Newton County constable J.W. "Wes" Harryman followed in a second car.[183]

Upstairs in the apartment, Blanche was playing solitaire, and Bonnie, still dressed in her negligee and house slippers, was recopying some of the poetry she'd previously written. Downstairs, Buck had just put away his car in the neighboring garage and was returning to the apartment garage when Clyde and W.D. came back to the apartment in the stolen Ford roadster. Buck opened the door for them as they backed the roadster into the garage. The gangsters started moving weapons from the roadster to the Ford sedan, which they planned to leave Joplin in the following day. One of them was just closing the garage door when the law officers drew abreast of the building. The state patrolmen cruised past the apartment and parked on the side of the road, but DeGraff, driving the second car, spotted the man at the garage door and pulled right into the driveway, blocking the escape of any vehicles parked inside. "Get in there as quickly as you can before they close that door," he shouted.[184]

As Harryman hopped out of the passenger's seat and started toward the door, one of the men inside, probably Clyde, opened fire with a sawed-off shotgun. Harryman was able to get off a single return shot before he fell to the ground at the garage entrance, mortally wounded with a severed artery. McGinnis then scrambled from the back seat and DeGraff exited the driver's side of the car with their revolvers drawn. McGinnis got off three shots before he was brought down by a volley of gunfire from inside the garage that virtually severed his right arm at the elbow. One of his shots or the single shot fired by Harryman struck Jones in the side, disabling him,

but Clyde was still blasting away. Crouching behind the police car, DeGraff had fired a couple of shots and was working his way around the automobile when McGinnis fell at his feet. He picked up the wounded officer's weapon and hurried around to the east side of the apartment. Meanwhile, Grammer raced from the troopers' car to the west side of the apartment, while his partner, Kahler, took up a position at the corner of a house west or southwest of the apartment and started exchanging shots with Clyde.[185]

Things were just as hectic inside the building as they were outside. Upon hearing shots fired, Blanche ran to look out the kitchen window but couldn't see anything. Buck came racing up the stairs without a weapon to tell the women they had to make a run for it right now. Bonnie quickly threw a few items into a suitcase while Blanche tried to corral her little dog, Snow Ball. Buck hurried back downstairs and took W.D.'s weapon as the wounded man stumbled upstairs and virtually collapsed in Blanche's arms. Some accounts of the Joplin shootout say that Bonnie herself grabbed a weapon and began firing at the lawmen from an upstairs window, but the preponderance of evidence suggests that she never fired a shot.[186]

Outside, DeGraff and Grammer met each other as they circled the house from opposite directions. DeGraff hollered for Grammer to go to the closest house and telephone for help, and the trooper raced toward the house occupied by Harold Hill. Kahler was now the only officer on the front side of the apartment who was not either dead or dying. With only one bullet left in his revolver, he dropped back to reload, and Clyde stepped out of the garage to fire another shot at the retreating officer. In trying to dodge the gunfire, Kahler stumbled and fell. Clyde apparently thought he'd hit his target and turned to go back in the garage. Picking himself up, Kahler fired his last bullet and slightly wounded Clyde in the chest. The slug hit a button on Clyde's shirt, barely penetrating the skin, and Bonnie later dug it out with a hairpin. Buck was also slightly wounded by a spent round that merely bruised his chest.[187]

Clyde and Buck had gotten the garage door open, but DeGraff's police cruiser and McGinnis's body were blocking the path of the Ford V-8, which the gang meant to use as the escape vehicle. Buck dragged McGinnis's body to the side while Clyde tried in vain to push DeGraff's automobile out of the way. Bonnie scurried down the steps from the apartment and piled into the front seat of the getaway car. Clyde ordered everybody else to get in the car, too, but as Blanche helped the injured Jones into the back seat, Snow Ball suddenly dashed out into the street. Blanche, instead of getting in the car, went running after the pet. Buck hollered for her to come back, and she

quickly retraced her steps and climbed into the back seat alongside Jones. Buck piled in beside her, and Clyde hopped in behind the wheel. Revving up the Ford's V-8 engine, he lunged the car forward, ramming the police car, and DeGraff's vehicle went rolling backward into the street and out of

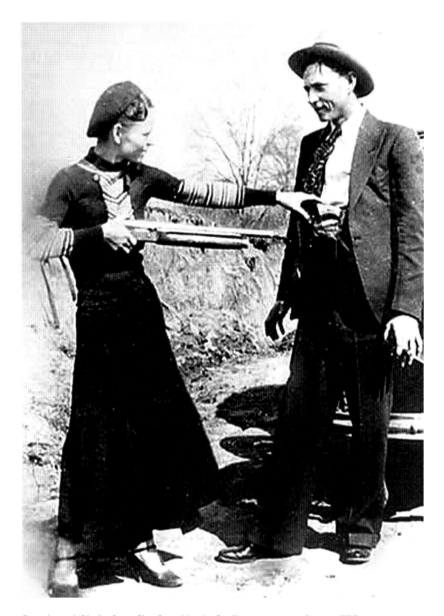

Bonnie and Clyde, from film found in the Joplin apartment. *Courtesy FBI.*

the way. The Ford sped out of the garage on to Thirty-fourth Street; turned south on to Main Street "running mighty fast," according to one eyewitness; and, at the Redings Mill bridge south of Joplin, was going so fast that Clyde almost lost control of the vehicle as he negotiated the curve leading on to the bridge.[188]

By the time additional law officers arrived at the garage apartment, the Barrow gang was long gone, and Wes Harryman lay dead. Harry McGinnis, severely wounded, was rushed to a local hospital but died later that night. Among the items found inside the apartment were an arsenal of weapons, a guitar, some diamonds and other jewelry identified as having been stolen in a burglary at nearby Neosho the previous night, a money sack from a Springfield bank, some clothing, two rolls of undeveloped film and a number of letters and personal papers, including Buck Barrow's pardon papers, Buck and Blanche's marriage certificate and a few poems that Bonnie had been working on at the time.[189]

One of the poems was "Suicide Sal," which she had been working on, off and on, since she'd started it a year earlier while serving a brief stint in a Texas jail after Clyde had abandoned her following a botched holdup. The poem told of a naïve country girl who fell in love with a slick gangster who lured her into a life of crime and then deserted her during a robbery attempt.[190]

Eyewitnesses reported that four people, two men and two women, made their escape from the garage apartment in the Ford V-8. From papers left behind in the apartment, the two men were quickly identified as brothers Clyde and Buck Barrow, and Blanche Barrow was identified as one of the women. The identity of the second woman was at first unknown, but by later that evening, she had been tentatively identified as Bonnie Parker. She, along with the Barrows, was reported to be well known to Texas police. No mention was made of W.D. Jones in initial accounts of the shootout.[191]

The rolls of film found in the apartment were developed by the *Joplin Globe*, and some of the photos, showing members of the gang, were printed in the April 15 edition of the local newspaper. The photos were sent out over wire service, and soon, pictures of the Barrow gang appeared in newspapers, magazines and newsreels across the country, bringing the gang, which had previously been little known outside Texas, nationwide notoriety. Several of the photos showed members of the gang in playful or otherwise staged poses, including one of Bonnie leaning against an automobile with one leg hiked suggestively on the bumper, a pistol in one hand and a cigar in her mouth. Bonnie, who had always wanted to be a star, suddenly was one, although perhaps not in the way she had imagined. She and Clyde were considered

romantic heroes by many Americans impoverished and devitalized by the Depression, and the gang's appeal was mainly due to Bonnie. However, it reportedly irritated her when the press started referring to her as Clyde's cigar-smoking moll because she smoked cigarettes, not cigars, and had only posed for the photo as a joke.[192]

After the Joplin shootout, the Barrow gang fled to Texas, where Bonnie suffered serious burns and other injuries in a car accident in mid-June. The gang then hid out in northwest Arkansas, but they were forced to abandon their plans to lie low after Buck killed a lawman near Alma on June 23. Over the next few weeks, the desperadoes stayed on the run while Bonnie recuperated (although her injuries would leave her never able to walk normally again). On the morning of July 18, the gang pulled off a string of filling station robberies in Fort Dodge, Iowa, and fled south. Late that night, they pulled into the Red Crown Cabins just outside Platte City, Missouri.[193]

Buck and W.D. hid beneath blankets in the back seat as Blanche, dressed in a pair of skintight riding britches that must have drawn attention, went to the adjacent Red Crown Tavern to check the gang into the double cabins, paying in coins for the two rooms. The clerk, Delbert Crabtree, noticed a man and a second young woman, who was covered with bandages, waiting in an automobile outside. Leery of the strange group, Crabtree notified Neal Houser, manager of the Red Crown complex, which also included a service station.

The gang parked their vehicle in one of the two garages that sat between and connected the cabins, and after they had gotten settled in, Blanche came back to the tavern for food and beer, again paying in coins. Houser walked back to the cabins with her to get the license number of his unusual guests' vehicle. Meeting the manager at the door, Clyde wouldn't let him into the cabin, saying his wife wasn't dressed, but instead he opened the garage door for Houser. The next day, July 19, Blanche again went to the office by herself to pay in coins for another night, and Houser also noticed that the occupants of the left-hand or westernmost cabin (i.e., Bonnie, Clyde and W.D.) always kept their curtains tightly drawn. His suspicions sufficiently aroused, he notified Missouri Highway Patrol captain William Baxter, and Platte County sheriff Holt Coffey was also contacted.[194]

Law enforcement officials knew that Bonnie Parker had recently been badly hurt, so when Baxter and Coffey got together to discuss the intelligence Houser had passed on to them, they suspected that the dubious characters holed up at the Red Crown Cabins might be the Barrow gang. While Coffey recruited a team of law enforcement officers to raid the cabins, Baxter

learned that the license number Houser had recorded from his suspicious guests' car matched the plate on a vehicle stolen in Enid, Oklahoma, in late June. Since the Barrow gang was suspected of that theft, it now seemed very likely that the men and women holed up in the Red Crown Cabins were the Barrows. Late in the afternoon, either Clyde or Blanche walked to a nearby drugstore to get fresh bandages and salve for Bonnie's wounds, and the druggist reported the purchase to Sheriff Coffey. The lawmen now felt sure they were facing the desperate Barrow gang.[195]

Knowing that Blanche had paid for the gang to stay another night, Baxter and Coffey decided to wait until after dark to raid the cabins. County deputies, highway patrolmen and Platte City police filtered in throughout the evening until a team of thirteen lawmen was milling about the Red Crown complex. Customers at the tavern and other nearby businesses began to realize that something was afoot, but the Barrow gang themselves were unaware that they were about to face a showdown.[196]

About 1:00 a.m. on the morning of July 20, the law officers closed in around the cabins with Coffey and Baxter leading the way. Jackson County deputy George Highfill steered an armored car (i.e., a regular car that had been reinforced with extra metal) up to the cabins and stopped in front of the garage where the gang's Ford V-8 was parked, blocking an exit. As he shined the car's headlights on the right-hand cabin, Sheriff Coffey knocked on the door of the cabin. Blanche jumped out of bed, woke Buck up and started putting on some clothes as she asked who was there. Coffey announced himself as the law, and Blanche, stalling for time, told him the men were in the other cabin. He ordered her to come out anyway, but by this time, Buck was at her side with a pistol tucked under his belt and an automatic rifle in his hands.[197]

The commotion roused Clyde in the other cabin, and he and W.D. grabbed their guns and started shooting, blasting through the doors and windows at the lawmen outside at about the same time Buck opened fire from the right-hand cabin. Sheriff Coffey and his nineteen-year-old son, Clarence, were both wounded in the barrage, and one or more of the bullets from the gang's high-powered rifles ripped through the metal of the armored car, striking Deputy Highfill. As Highfill backed his vehicle away from the garage door to safer ground, another shot struck the vehicle's horn, causing it to blare loudly. The other officers, unable to see well in the dim light, momentarily stopped shooting, thinking the horn was some sort of signal to cease fire.[198]

Highfill's retreat cleared an escape route for the Ford V-8 parked inside the garage, which had a door leading directly into the left-hand cabin. Bonnie

hobbled to the car, while Clyde helped W.D. get the garage door open. W.D. then climbed into the vehicle, and Clyde slid in behind the wheel and started the engine. Buck and Blanche heard the Ford V-8 start up, and they knew that now, during the momentary lull in firing, was the time to make a run for it. Unlike the other cabin, theirs had no direct access to the garage, and they burst out of the front door with Blanche in the lead. They were about halfway to the car when the posse opened up with a volley of gunfire, and Buck was brought down by a shot from a high-powered rifle that struck him in the head, taking away part of his skull. Hysterical, Blanche raced back to her husband. Clyde, seeing his brother seriously wounded, braved the torrent of lead to help her get Buck to the car, while W.D. provided cover fire.[199]

With all the gang in the Ford, Clyde jumped behind the steering wheel and floored the accelerator. The car careened out of the garage through a hail of lead as W.D. continued to return fire. One of the lawmen's bullets shattered the Ford's back window, and shards of glass sprayed into Blanche's eyes, inflicting an injury that would eventually result in her losing her sight in one eye.

The lawmen did not pursue the desperate, battered gang as they made their escape. Buck was gravely wounded, Blanche was virtually blind, Bonnie was still in bad shape and W.D. had received minor injuries in the shootout. Clyde headed for Iowa to try to find a place to hide out. He finally stopped to camp at Dexfield Park, named for its location between Dexter and Redfield about thirty-seven miles west of Des Moines. On July 24, Buck was seriously wounded again in a shootout at the park, and he died a few days later. Blanche was captured during the shootout, while Bonnie, Clyde and W.D. once again made their escape, although all three sustained wounds.[200]

The remaining three members of the gang fled west to Colorado and then crisscrossed the country, pulling off small robberies along the way for spending money. Later in Texas, W.D. left the gang, and Bonnie and Clyde secretly reunited with their families. In January 1934, the pair helped break Raymond Hamilton, an old partner of Clyde's, and several other inmates, including Henry Methvin, out of the Eastham Prison between Dallas and Houston. Less than a month later, Bonnie, Clyde, Hamilton and Methvin, forming the latest incarnation of the Barrow gang, made their appearance in Missouri.[201]

On February 12, 1934, the gang stole a car from the Thompson Tire Company in Springfield and fled in it and a red Chevy sedan. They were

spotted as they roared through Hurley about twenty-five miles southwest of Springfield, with Clyde at the wheel of the Thompson car and "his cigar-smoking sweetheart," as one newspaper called Bonnie, at his side. Authorities in Galena were notified, and Stone County sheriff Seth Tuttle and three deputies started out in search of the gang. They met the two bandit cars traveling at a high rate of speed on the highway just north of Galena, and they turned around to give chase. The lawmen found the car that had been stolen in Springfield abandoned about two miles east of Galena. The sheriff took charge of the abandoned vehicle, while the deputies resumed the pursuit.[202]

Meanwhile, the Barrow gang had all piled into the Chevy sedan after ditching the Thompson automobile, and they continued their flight toward Reeds Spring, where Constable Dale Davis, informed of their approach, had set up a roadblock near the underpass leading into town. Upon seeing the lawman, the outlaws turned around and started back the other way. Davis gave chase, but the Barrow gang showered his car with a fusillade of bullets that forced him into a ditch. After retreating a short distance, the gang turned south on to a side road and came upon a local man named Joe Gunn walking along the road. They stopped and forced him into the back seat, demanding that he pilot them to Arkansas.[203]

The Barrow gang came out on the farm-to-market road between Cape Fair and Reeds Spring and turned east. A short distance down the road, they met the Stone County deputies who had continued through Reeds Spring and doubled back to the west. The two cars stopped about two hundred yards apart. Armed with machine guns and automatic rifles, Clyde, Hamilton and Methvin got out and sprayed the lawmen's car with lead. The deputies returned fire as best they could, but they were armed only with pistols and shotguns and had little ammunition. During the shootout, Bonnie, "the auburn-haired bandit queen," reportedly sat in the front seat squealing with delight and busied herself reloading Clyde's weapon for him after he'd emptied it. When the deputies ran out of ammo, Clyde and his sidekicks piled back into the Chevy and roared past the lawmen's disabled vehicle. Near Berryville, Arkansas, the gang kidnapped another man but let both him and Gunn out a short time later between Berryville and Eureka Springs. Years later, Gunn recalled that Bonnie "cursed a lot" during his brief ride with the gang, and he further embellished his tale by claiming that she participated in the two shootouts, showering both Constable Davis's car and the Galena deputies' vehicle with bullets.[204]

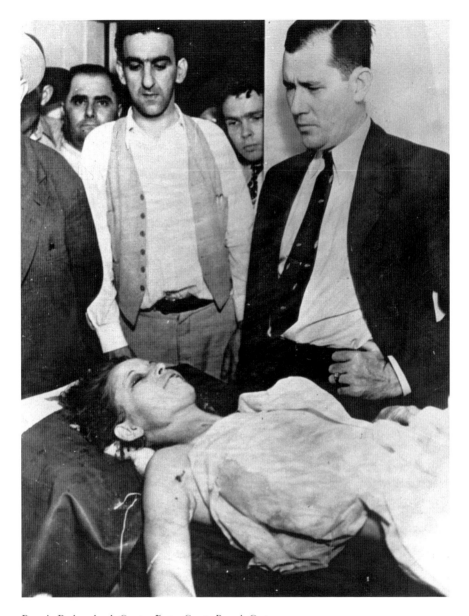

Bonnie Parker dead. *Courtesy Jasper County Records Center.*

After the Reeds Spring shootout, Bonnie and Clyde continued their desperate crime spree for another three and a half months before they were finally killed in a police ambush near Sailes, Louisiana, after Methvin betrayed them.

MA BARKER AND HER
MURDEROUS SONS

Ma Barker has been widely portrayed in film and literature as a criminal matriarch who ruled her sons and their gang with an iron will, masterminding, if not directly participating in, their villainous deeds and enjoying the extravagant lifestyle that the fruits of their crimes afforded her. This depiction arose, for the most part, posthumously, and the FBI was a coconspirator with the media in shaping such an image. After Ma and her son Fred were killed in Florida in 1935, FBI director J. Edgar Hoover claimed, in part no doubt to justify the fact that his agents had killed an old woman, that Mrs. Barker was "the most vicious, dangerous, and resourceful criminal brain of the last decade."[205]

Those in a position to know, however, swore that such an exaggerated description was nonsense. Notorious Barker gang member Alvin Karpis said years later that Ma was just "an old-fashioned homebody" who was gullible, simple and generally law abiding. He claimed the idea that she was the mastermind behind the gang's activities was "the most ridiculous story in the annals of crime." Karpis said that Mrs. Barker not only was not a leader of criminals but she wasn't even a criminal herself and that her only role was in providing cover for the gang so that they would look more innocent and draw less attention when they traveled. Bank robber Harvey Bailey, who was well acquainted with the Barkers, corroborated such a view, saying in his autobiography that Ma Barker "couldn't plan breakfast," much less an elaborate crime.[206]

Instead of a criminal mastermind, Ma Barker was mostly just an overindulgent mother who felt her sons could do no wrong. Her husband, George, occasionally tried to discipline the boys when they were growing up, but more often, he just stayed out of the way because Ma always overruled him anyway. She not only seemed to tolerate her sons' misdeeds but also did everything she could to get them out of trouble whenever they came in conflict with authorities.[207]

Ma Barker was born Arizona "Arrie" Clark near Ash Grove, Missouri, about 1874. Her father, John Clark, either died or left home not long after Arrie was born. Her mother, Emeline, remarried Reuben Reynolds. By 1889, the family had moved to Lawrence County, and in 1892, Arrie married George E. Barker in his hometown of Aurora. The couple took up residence in Aurora, and the three eldest sons, Herman, Lloyd and Arthur "Doc," were born there. George and Arrie moved prior to the 1900 census, but exactly where is not clear. Ten years later, however, the family was living in Christian County, Missouri, and a fourth son, Fred, had joined the family. Shortly after the time of the 1910 census, the Barkers moved to Webb City, Missouri, in Jasper County. George found work in the area lead mines while Ma took care of raising the boys.[208]

After the Barker gang had become notorious, Webb City residents recalled that the eldest son, Herman, as a teenager, liked to imitate his hero Jesse James by riding his pony into the town's bars and pretending to shoot

up the place. Herman first got into serious trouble with the law when he and a sidekick held up five men who were playing pitch in the back room of a grocery store in Webb City in the wee hours of Sunday morning, March 7, 1915. Herman Barker was arrested on suspicion late Monday afternoon, but Ma soon got him released. Reportedly declaring that she could no longer live in such a suspicious place, she packed up the family and moved to Tulsa.[209]

Contrary to popular legend, Ma Barker was mostly just an overindulgent mother. *Courtesy FBI.*

In Tulsa, Ma's boys fell in with the Central Park Gang, a loose confederation of about twenty-two young hoodlums and thieves. After brief apprenticeships with the Tulsa gang, the Barker boys struck out across the Midwest, committing crimes ranging from burglary to murder. Leaving Tulsa in about 1916, Herman was in and out of jail in Missouri, Minnesota and other states over the next eleven years, escaping or being released on parole each time. In January 1922, Lloyd Barker was sent to the federal prison at Leavenworth for robbing the U.S. mail in Baxter Springs, Kansas. The following month, Doc was sentenced to life at the Oklahoma State Prison in McAlester for killing a night watchman at a Tulsa hospital. When he was just a kid, Fred Barker, Ma's youngest son, stayed with family friend and underworld figure Herb Farmer in Joplin, Missouri, for a period of time and, according to the FBI, likely "received considerable education in the school of crime from Farmer." As a young man, Fred put his "education" to work, and he had already been arrested several times when he was charged in a burglary and grand larceny at Winfield, Kansas, in 1926. He was convicted and sentenced to five to ten years in the state prison in Lansing. Herman was still on the run and the only Barker brother not behind bars when he got into a shootout with police in Wichita, Kansas, in 1927. Badly wounded during the confrontation, Herman turned his gun on himself and committed suicide rather than be taken alive or killed by police. Ma and George brought their eldest son back to Oklahoma and buried him at the Williams Timberhill Cemetery near Welch.[210]

Not long after Herman's death, George Barker left Ma, reportedly because she was hanging around other men, and went back to Webb City, where he spent the rest of his days running a service station. Ma soon moved in with an alcoholic billboard painter named Arthur Dunlop, and she was listed in the 1930 Tulsa census as "Arrie Dunlop," although the couple never legally married. With Herman dead, all of her other sons in prison and her husband gone, Ma lived in terrible poverty, even after she moved in with Dunlop, who was mostly jobless. For a while, she depended on Herman's widow, Carol Hamilton Barker, for food, but she didn't get along with Carol or any of her sons' women. According to FBI files, Ma was "very jealous of her boys" and resented any women who might come between her and them.[211]

Fred Barker was paroled from the Kansas State Penitentiary on March 20, 1931, and he moved into a house in Joplin with another ex-con. After Alvin "Creepy" Karpis, whom Fred had become acquainted with in prison, was paroled on May 10, he contacted Ma Barker in Tulsa. She sent a telegram to her son in Joplin. Fred soon joined Karpis in Tulsa, and they and two or three sidekicks pulled off a string of small-time burglaries in the

Tulsa area. Both men were arrested, but Karpis was immediately paroled again and Barker escaped.[212]

In early October 1931, Arthur Dunlop and Ma Barker rented a house two miles east of Thayer, Missouri, giving their names as Mr. and Mrs. Arthur W. Dunlop, and Karpis and Fred Barker soon joined them there. After committing a string of crimes in the area, Karpis and Barker drove a 1931 DeSoto into a garage in West Plains, Missouri, on Saturday morning, December 19, to have two spare tires patched. The car was recognized as one that was thought to have been used in the burglary of a local clothing store two nights earlier, and local authorities were quickly notified. Howell County sheriff C.R. Kelly showed up to investigate, and as he approached the driver's side door, Barker opened fire from the passenger seat. Kelly collapsed and died almost instantly, but Barker stepped out of the DeSoto and came around to the driver's side to make sure. Meanwhile, Karpis gunned the car and careened out of the garage, leaving Barker to make his escape on foot.[213]

Law officers traced Sheriff Kelly's killers to the hideout near Thayer, but when they raided the place, the gang had already left. Found in the house were letters and photos belonging to the Barker gang and almost all the merchandise taken in the clothing store burglary. The West Plains police chief and Lulu Kelly, who succeeded her murdered husband as the county sheriff, offered rewards for the arrest and conviction of the gang members, including $100 for "Old Lady Arrie Barker, Mother of Fred Barker." This was apparently the first official notice of Ma Barker."[214]

The Barker gang fled to Joplin and stayed briefly with Herb Farmer, who advised them to go to St. Paul, which was known among criminals as a "safe" city where corrupt local law enforcement officers would leave them alone as long as they paid for protection. Through underworld connections made in St. Paul, the Barker-Karpis gang soon grew into one of the most effective and active criminal gangs in the country, pulling off a string of crimes that included robbing a Minneapolis bank in late March 1932 of over $250,000. In late April, Arthur Dunlop's body was found near Webster, Wisconsin, and it was thought that Fred Barker and Alvin Karpis had killed him as a suspected informer.[215]

To escape the heat brought on by the murder, the gang temporarily moved back to Missouri, with Ma Barker, her son Fred and Karpis renting a place at the Longfellow Apartments in Kansas City on May 12, 1932. Other gang members lived in the area as well. On June 17, Fred Barker, Karpis and other gang members robbed a bank in Fort Scott, Kansas, of $47,000, after which

the gang returned to the Barker-Karpis apartment for a lavish celebration party. Ma, Fred and Karpis checked out of the Longfellow Apartments on July 5 and rented an apartment at 414 West 46th Terrace in Kansas City as "Mrs. A.F. Hunter and sons." Here, according to FBI files, Ma Barker, who somewhere along the line started calling herself "Kate," served as a housekeeper for Fred and Karpis. For a few days, the group "enjoyed the homelike atmosphere which Ma Barker endeavored to create." They stayed at the West 46th Terrace apartment just a few days, though, before heat from the FBI forced them to abscond, and they went back to Minnesota. From their headquarters there, the gang ventured into Kansas in late July to rob a bank in Concordia of $250,000.[216]

Paroled on September 30, 1932, Doc Barker visited his father in Missouri for a few days and then joined the gang in Minnesota. During the next year and a half, the gang pulled off a string of daring bank robberies, killed four policemen and at least one innocent bystander in the process and carried out two kidnappings of wealthy businessmen, netting a combined $300,000 in ransom. Karpis and Doc Barker were identified as participants in the second kidnapping, and their names were added to the FBI's wanted list.[217]

Desperate to disguise their identities, Karpis and the Barker brothers went to Chicago, where a quack underworld doctor performed operations on their faces and fingertips. In April 1934, a gangster named Eddie Green, who had formerly been a member of the Barker-Karpis gang, was shot and captured in St. Paul. Green and his wife provided extensive information about the Barker-Karpis gang, including the fact that Karpis and the Barker brothers traveled with an old woman who "posed" as their mother. Although individual members of the Barker-Karpis gang were wanted for various crimes, this was apparently the first time the FBI was aware of the gang as an organized criminal enterprise. Closing in on the gang, agents arrested Doc Barker outside his Chicago apartment on the evening of January 8, 1935, and inside the apartment, they found a Florida map with the area of Ocala circled. Doc refused to explain what it meant, but later that same night, agents raided another apartment in Chicago, killing an old pal of the Barkers from their Tulsa days and capturing three other associates of the gang. One of the captured gang members told the FBI that Fred Barker and his mother were living on a lake in Florida.[218]

Tracking Ma and Fred to a house on Lake Weir in Ocklawaha, Florida, FBI agents surrounded the place early in the morning on January 16, 1935. When the officers demanded the surrender of the occupants, Fred Barker answered with a blast of fire from a machine gun. The FBI agents responded

with tear gas, rifle fire and machine gun fire of their own. After a four-hour gun battle during which more than 1,500 rounds of ammunition were poured into the house, the agents sent the Barkers' handyman into the cottage to see whether anyone was alive. Fred Barker's body, riddled with bullets, was found in an upstairs bedroom, and Ma lay dead nearby with a single gunshot wound. Agents found a machine gun lying near Ma's left hand when they entered the house, and although the gun was near enough to Fred's body that it could easily have been his and likely was, the official FBI report claimed that "Kate Barker battled until death." Newspapers sensationalized the story even more, claiming that Ma Barker was found inside the house with a smoking machine gun clutched in her hands. Thus was born the legend of Ma Barker, the gun-toting mama.[219]

Ma's and Fred's bodies sat in the Ocala morgue until October 1935, when George finally brought them back to the Williams Timberhill Cemetery near Welch and buried them next to his son Herman.[220]

Chapter 9

THE SEXTRAORDINARY SALLY RAND

Unlike most of the other women in this book, burlesque dancer Sally Rand never committed a serious crime like horse stealing or murder, but her scandalous behavior brought her just as much notoriety as the others. Sally was arrested on multiple occasions for her supposedly lewd performances, most notably at the 1933 Century of Progress exposition in Chicago. Asked about her career a few years later, she waxed philosophic, admitting that she might have wished for a different path to fame and fortune but that she took the opportunity that presented itself. "At any rate," the feisty Rand reportedly added, "I haven't been out of work since the day I took my pants off."[221]

Sally was born Helen Gould Beck in 1904 in the rural community of Elkton, Hickory County, Missouri, to William Beck, an army officer, and Nettie Grove Beck, a schoolteacher and newspaper correspondent. As Sally explained many years later, her parents were actually living in Springfield, fifty miles to the south, until about two months before her birth. "Then my mother moved up to my grandfather's farm," Sally told a Springfield newspaperman in 1970, "so I could be born in the same house—in the same bed, I reckon—where she was born."[222]

When Sally was a toddler, the family moved to Kansas City, where, as a six-year-old, she saw the famous ballerina Anna Pavlova perform at Convention Hall. From that moment on, Sally aspired to be a dancer. Her first job in show business, when she was just thirteen years old, was as a chorus girl at a Kansas City nightclub, the Empress Theatre, where she caught the eye of

Helen Gould Beck (aka Sally Rand), *left*, as a college student at Columbia College. *Courtesy Fred Pfister and Columbia College.*

Goodman Ace, drama critic of the *Kansas City Journal*. Ace introduced her to Gus Edwards, whose School Days juvenile vaudeville troupe had developed such stars as Eddie Cantor, Lila Lee and George Jessel. Sally joined the company and studied dance, voice and drama. Sally also occasionally worked odd jobs on the fringes of show business, such as serving as an artist's model. She still found time to graduate from Kansas City Central High School and briefly attend Christian College (now Columbia College) in Columbia, Missouri, as a young woman.[223]

Lacking funds to continue her education, Sally dropped out of college in 1922 and went to Hollywood, where she found work as a Mack Sennett "bathing beauty." She appeared in publicity and comedy shorts, performing stunts like diving from a tall ladder into a small tank of water. Using the stage name Billie Bett, she soon progressed to more serious roles, and Cecil B. DeMille signed her to his stock company and cast her as the slave of Mary Magdalene in *The King of Kings*. DeMille, who called her the most beautiful girl in pictures, suggested she change her name to Sally Rand, supposedly picking the name after glancing at a Rand-McNally map. She went on to have starring and supporting roles in a number of silent films from the mid- to late 1920s, and she was named a WAMPAS Baby Girl in 1927, a designation given each year by the Western Association of Motion Picture Advertisers to a small number of young actresses whom the organization felt were on the verge of stardom. Her list of onscreen credits includes *The Dressmaker from Paris*, *Man Bait*, *The Night of Love*, *Getting Gertie's Garter*, *His Dog*, *The Fighting Eagle* and *A Girl in Every Port*.[224]

When silent films gave way to talkies in the late 1920s, Sally's prominent lisp prevented her from making the transition to the new medium, and she was relegated to bit parts. With the coming of the Depression, she found herself facing hard times, and she did what she could to survive, including a brief stint as an acrobat with the Ringling Brothers Circus.[225]

Despite her flirtation with Hollywood stardom and her eventual fame, Sally never forgot where she came from, and she made periodic returns to Missouri, including a visit to Hickory County in about 1930. Barbara Driver, whose family was from the Elkton area, recalled the visit in 2001, remembering that Sally arrived in Weaubleau by airplane. "It landed in a nearby pasture, and there was quite a turnout to see her," Mrs. Driver said.[226]

In 1932, Sally arrived in Chicago as part of a traveling burlesque show called *Sweethearts on Parade*, but she gave up vaudeville later the same year for a chance to appear in legitimate theater and use her training as a ballet

dancer in Fritz Blocki's *The World Between*. The play was a critical success but a financial failure, and it closed after only a few days.[227]

After the closure, a friend took Sally around to Chicago nightclubs to help her find work. "When all the theaters in America close and you are a ballet dancer, what are you going to do?" Sally asked rhetorically by way of explanation many years later. She remembered being astonished by the tiny stages in the speakeasies, and she knew she wasn't going to be dancing ballet on them. "There was always a girl standing up there singing pseudo French and party songs in a little cutie-pie costume," Sally said. Despite her initial uneasiness, she took a job at one of the speaks, the Paramount Club. It was here that she first started doing the dance that would make her a household name.[228]

Sally got the idea for her famous fan dance, she said, from watching white herons in the moonlight as a child on her grandmother's farm back in Missouri. She found two large pink ostrich feathers at a costume shop in Chicago and choreographed the dance to the strains of Debussy's "Clair de Lune" and Chopin's "Waltz in C Sharp Minor." Moving rhythmically to the music with the stage lit in moonlight blue, she danced nude, or nearly so, behind the feathers she manipulated in front of her, occasionally showing audiences a bare leg or a glimpse of derriere. "The sexiest thing I'd ever done up until then was 'Scheherazade' in the ballet," she recalled years later.[229]

Although biographical sketches of Sally Rand routinely contain the assertion that she "danced nude," she was actually covered by white body powder or a sheer body suit during most of her performances. Sally's act was all about illusion, and its success lay in her ability to make audiences think they had seen something, even if they hadn't. "The Rand is quicker than the eye," Sally told reporters, and she soon parlayed the catchy phrase into a promotional slogan.[230]

Sally's performances at the Paramount were successful enough that she sometimes made as much as sixty dollars a night, but in the spring of 1933, with the World's Fair coming to Chicago, Sally dreamed of bigger things. She tried to get a job dancing at the fair's "Streets of Paris" concession but was turned down. On the evening before the scheduled opening of the fair, officially called the Century of Progress International Exposition, Mrs. Randolph Hearst hosted a fancy ball for the society women of Chicago as a preamble celebration, and Sally decided to crash the party as Lady Godiva, either as a publicity stunt or, as she later claimed, in protest of the extravagant dresses the women planned to wear when most folks could scarcely afford to clothe themselves. She was not admitted to the society

gala, but her gallop through the streets of Chicago wearing nothing but a very long blonde wig caused a sensation and got her hired the next day as the lead performer in the "Streets of Paris" sideshow.[231]

Although Sally Rand's act might be considered rather tame by present-day standards, this was decidedly not the case in 1933. Her fan dance outraged the clergy and the polite society of Chicago, and she soon found herself in court answering charges of lewdness and indecent exposure. The publicity surrounding her arrest only heightened the interest in her act, and when she was released and allowed to go back to performing her fan dance, spectators flocked to see her by the thousands. Although the Century of Progress Exposition was supposed to highlight scientific achievements, a newspaperman at the time noted that "the Adler Planetarium is playing to poor business; 40 men could toss a medicine ball around in the Hall of Science and never bother the customers…But Sally Rand dancing nude on the Streets of Paris has been jamming the place nightly."[232]

Sally's salary at the start of the fair was $125 a week. By the end of the summer, she was making $3,000 a week and had rocketed to worldwide fame. Sally Rand became a household name, as even schoolchildren got into the spirit, telling jokes and repeating jingles about Sally Rand: "Sally Rand has lost her fan. Don't you look, you nasty man."[233]

When the World's Fair reopened in 1934, Sally decided she needed something new to maintain interest in her act, and she came up with the bubble dance. As the headliner of a big show involving twenty-four dancers and sixteen showgirls, Sally danced slowly behind a large, transparent or translucent balloon wearing next to nothing, and the act was almost as big a hit as her fan dance had been the previous year.[234]

After the sensation caused by Sally's appearances at the Chicago World's Fair, she was sought as an exotic dancer all across the country. However, she didn't like the term "exotic" because she considered her dancing artistic. "Exotic means strange and foreign," she reportedly told a reporter who referred to her as an exotic dancer. "I'm not strange, I like men; and I'm not foreign, I was born in Hickory County, Missouri."[235]

Not only did Sally's Chicago appearances catapult her to fame as a sensual dancer, but they also reopened doors that had previously been closed, reviving opportunities for her to try her hand once again in movies and serious theater. In 1934, she danced and had a small speaking part in *Bolero*, and the following year, she was cast as prostitute Sadie Thompson opposite Humphrey Bogart in a summer theater production of *Rain*. Prior to landing the role, Sally, who had tired of playing nothing but simpering ingénues in

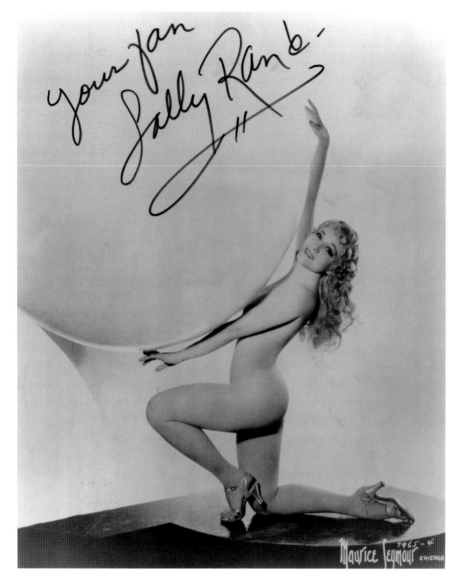

A publicity shot of Sally Rand and her bubble dance, circa 1935. *Courtesy Fred Pfister.*

Hollywood during the '20s, reportedly told friends, "When I try my hand at acting, I want to play a trollop. That's what everyone thinks I am anyway."[236]

Apparently, Sally was convincing in the role of a fallen woman. The director of the play lauded her for her "inherent dramatic talent," and a *Newsweek* headline declared, "Sally's Sadie Proves the Fans Concealed an Actress."[237]

Despite her critical acclaim in *Rain*, Sally was soon back on the road performing her trademark hide-and-peek dances. She appeared at the California Pacific Exposition in San Diego in 1935–36, and later in 1936, she opened a "nude show" at the Frontier Exposition in Fort Worth. Although her bare-all performances caused a stir, her dancing was so lovely, according to a later observer, that it transcended burlesque, and "public opinion overrode the moral objectors." At San Francisco's Golden Gate Exposition in 1939, Sally hosted Sally Rand's Nude Ranch, featuring women wearing gun belts, cowboy boots and hats and not much else.[238]

Sally continued to appear at expositions and state fairs throughout the '40s and '50s. In 1941, she came back to her old Missouri stomping grounds to appear at the Ozark Empire Fair in Springfield. Hired by a kinsman for a bargain fee of $1,500 for two performances on successive nights, Sally had so much fun seeing friends and relatives that she stuck around for a third night for only $300 more. Describing her performance, a local newspaperman said Sally started her act dressed in a white evening dress and carrying two large white fans. Dancing and whirling gracefully across the stage, she paused in a soft blue spotlight, where she dropped her dress and, covered only by the two huge fans, completed her dance. Another reporter pronounced her act "an artistic, graceful performance," but he added that he thought some spectators had come away dissatisfied because they had come to the show not quite sure what to expect, and "after it was over, they weren't quite sure what they had seen." Sally dismissed the controversy with her standard comeback that the Rand was quicker than the eye. At any rate, Sally's appearance helped attract a record attendance of 175,000 people and was credited with saving the financially struggling Ozark Empire Fair.[239]

Sally married for the first time in 1942 to rodeo performer Thurkel Greenough. The marriage lasted only a couple years, and after the divorce, she adopted an infant son, Sean, while she was single. In 1950, she wed Harry Finkelstein, but her second marriage lasted just a couple years, too. Her third marriage, in 1954 to Frederick Lalla, was annulled.[240]

In 1951, Sally came back to her home state again, this time for the Missouri State Fair in Sedalia. According to a later report, the effervescent Sally "made personal appearances, granted interviews, made dignified talks to businessmen—and worked ten to twelve shows a day." Sally, of course, was a hit, and the fair's gate receipts surged 32 percent over the previous year. In later years, Sally came back to the Missouri State Fair twice more, "each time with the same electrifying effect on attendance."[241]

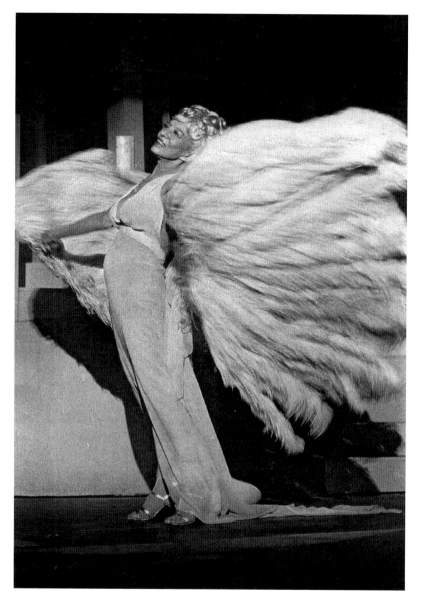

Sally Rand was still showing off her fans, circa 1960. *Courtesy Fred Pfister.*

By the 1950s, Sally had earned a reputation as more than just a provocative dancer. In August 1954, during a long run in Las Vegas at the Silver Slipper, where she was entertaining audiences with her fan dance four times a night, she landed a job at KLAS-TV, Vegas's only television

channel, hosting a talk show during which she interviewed fellow show business people and advised her predominantly female audience on matters of beauty and other topics. *Newsweek* commented at the time that Sally had previously "shown her versatility by sharing a rostrum with Gene Tunney to discuss Shakespeare and by giving 1,300 Harvard freshmen a lecture on the evils of Communism."[242]

Standing only five feet tall, the petite Rand maintained her girlish figure and was still strutting her stuff into the 1960s and '70s. On April 7, 1972, sixty-eight-year-old Sally stepped off an airplane in Kansas City dressed in spike heel sandals and a miniskirt in advance of her scheduled performance at Union Station, where she wowed audiences the next night with her fan dance. A week later, Sally went to a homecoming of Columbia College alumnae in Columbia, where she talked about an autobiography she was working on, discussed the philosophy of Santayana and signed autographs with her trademark "Your fan, Sally Rand."[243]

Even becoming a grandmother in 1974 when her son, Sean, and his wife had a daughter didn't slow Sally down. "What in heaven's name is so strange about a grandmother dancing nude?" she asked. "I'll bet lots of grandmothers do it." Known for her pithy one-liners, Sally also once suggested that restaurant owners in cities where she played should offer a "'Sally Rand Salad'—one without the dressing."[244]

In 1976, at age seventy-two, Sally came back to Columbia College for another visit and, saying she wanted to be treated like one of the girls, stayed for a week in the college dormitory. During her stay, she performed her famous fan dance and lectured a psychology class on human sexuality.[245]

Sally Rand died on August 31, 1979, at the age of seventy-five, in Glendora, California, where she had lived for many years. The *New York Times* observed in its obituary of Rand that, in her later years, her fan dance had come to be seen as charming and, despite her still-youthful figure, devoid of prurience. Speaking of the sensation she had caused over forty-five years earlier when she'd first introduced her fan dance, the *Times* added, "Although it did not seem so at the time, Miss Rand was actually rescuing the sexually provocative dance from the strip-tease joints and making its derivative forms respectable for the legitimate stage."[246]

Not a bad legacy for a girl from little Elkton, Missouri.

Chapter 10

BONNIE HEADY AND THE GREENLEASE KIDNAPPING

A few minutes before eleven o'clock on Monday morning, September 28, 1953, forty-one-year-old Bonnie Brown Heady got out of a taxi in front of the French Institute of Notre Dame de Sion in the Hyde Park neighborhood of Kansas City on the Missouri side of the state line. Dressed fashionably in a skirt, blouse, hat and white gloves, the plump but not unattractive Heady instructed the driver to wait. Then she walked up the steps of the exclusive Catholic grade school and rang the bell. Sister Morand, a French nun, answered the door and let the unknown caller inside, even though the school was normally careful about admitting visitors.[247]

Heady identified herself as the aunt of Bobby Greenlease, six-year-old son of wealthy Kansas City automobile dealer Robert Cosgrove Greenlease. Heady told the nun that the boy's mother, Virginia, had suffered a heart attack, and she needed to take Bobby to the hospital. Sister Morand invited the woman, who seemed upset, to step into the chapel and pray while she fetched the little boy. "I'm not a Catholic," Heady mumbled as she entered the chapel. "I'm not sure if God will answer my prayers."[248]

When Sister Morand returned with Bobby minutes later, Heady came out of the chapel to meet them and repeated inanely that she, a supposed member of the devoutly Catholic Greenlease family, was not a Catholic. She was not sure God would answer her prayer. However, her disavowal of Catholicism did not arouse suspicion, nor did the fact that she was a stranger seem to concern the little boy. He took the woman's hand and let her escort him out of the building.[249]

Heady got back into the taxi with Bobby and told the driver to take them to the Katz Drug Store at Fortieth and Main, near where she had engaged the cab about a half hour earlier. The cabby took the woman and the boy to the designated spot, less than a mile southwest of the school, and let them out in the drugstore parking lot, where Heady's thirty-four-year-old boyfriend, ex-con Carl Austin Hall, waited in her Plymouth station wagon.[250]

Bonnie Emily Brown was born into a prosperous farm family in Nodaway County, Missouri, on July 15, 1912. At Hazel Dell Elementary School in Clearmont, Bonnie was a quiet, obedient girl. Later, at Clearmont High School, she made the honor roll during her senior year. She enrolled in college in Maryville but dropped out after just a few months and went to work in a beauty salon. In June 1932, she married Vernon Heady, more than ten years her senior. He became a successful livestock merchant, and the couple lived comfortably in a large home in St. Joseph. Bonnie's closets were packed with nice clothes, and her dresser was crowded with jewelry and perfume. She became an accomplished horsewoman who often rode in public parades, and the couple enjoyed going to square dances and raising and showing pedigree boxers. The marriage, however, was childless and unhappy. Vernon Heady did not want children and reportedly forced his wife to have several abortions until Bonnie, who had wanted kids, grew to dislike children herself.

In 1948, she inherited $44,000 and a large farm from her father, but by then, her marriage was on the rocks and she had taken to drink, sometimes showing up drunk in public places. In September 1952, Bonnie sued her husband for divorce on the grounds of adultery, and when the divorce was granted one month later, she received the couple's home in St. Joseph in the settlement. Soon afterward, a strange man moved in with her, and they started having loud parties. Meanwhile, Heady continue to indulge her affinity for fine clothes, shopping at exclusive women's stores in various cities. As her money began to run out, she turned to prostitution to support her lifestyle, servicing men out of her home at $20 a trick. Sometime in the spring of 1953, she hooked up with Carl Austin Hall at her favorite pick-up joint, the Pony Express Bar in St. Joseph, and took him to her bed. Almost from the moment they met, though, Hall somehow seemed different to her from her other johns. The pair ended up spending the night together, and two days later, they started living in Heady's home as man and wife.[251]

Carl Hall came from an even more privileged background than Heady. His father was an attorney and prominent citizen in Pleasanton, Kansas, and his mother was the daughter of a judge. The couple's first child died

young, and Carl, born on July 1, 1919, grew up as a spoiled only child. The father died when Carl was thirteen, and he became increasingly unruly after that. His mother sent him to Kemper Military School in Boonville, Missouri, where one of his classmates was Paul Robert Greenlease, an adopted son of Robert Cosgrove Greenlease. Hall saw action with the U.S. Marines during World War II, but he started getting into trouble for habitual drunkenness and being AWOL. He was discharged under less than honorable conditions in early 1946, but he suddenly found himself a wealthy man when he inherited most of the family fortune about the same time. Hall ran off with a married woman, wed her as soon as her divorce came through and moved to a fashionable neighborhood of Kansas City, Missouri, not far from the even swankier suburb of Mission Hills, Kansas, where the Greenleases lived. Over the next few years, Hall squandered his fortune through gambling, heavy drinking and bad business ventures, and his wife divorced him in 1950. Broke and despondent, Hall turned to crime, and he was arrested in 1951 for a string of taxicab robberies and sent to the Missouri State Prison.[252]

Paroled in April 1953, Hall went to St. Joseph, where he met and moved in with Bonnie Heady one month later. She fell for him hard, but Hall saw her more as an accomplice than a lover. Taking over as her pimp, he marketed her to other men and regularly beat her, but the degradation only heightened her dependence on him. It was mutual desperation and a shared addiction to alcohol, not love, that kept them together. Realizing he'd found someone whose craving for the good life equaled his own, Hall started revealing details to Heady, little by little, of the get-rich-quick scheme he'd begun to hatch while still in the pen. He told her that kidnapping was the best method of getting a large sum of money in a hurry with little chance of being caught, and he mentioned the Greenlease family as his target. At first, Heady dismissed the idea as mere talk, but she gradually let herself be convinced after Hall assured her that he would cover for her if anything went wrong. Only after the two were well into the planning of the crime and Bobby Greenlease had been chosen as the victim did the psychopathic Hall hint at the idea of killing the boy, mentioning that the kid might be able to identify them and would be "evidence" if they didn't get rid of him. Drinking up to two fifths of whiskey a day and living in a constant alcoholic stupor, Heady finally gave in to Hall's smooth talk and agreed not only to the murder but also to burying the boy's body in the backyard of her home.[253]

Now, with the kidnapping having been accomplished, she and Hall took the boy to an isolated farm in Johnson County, Kansas, about twelve miles southwest of downtown Kansas City near the present-day intersection of

Six-year-old Bobby Greenlease with his father shortly before his murder. *Courtesy the St. Louis Post Dispatch.*

Ninety-fifth Street and Highway 69. Hall drove down a lane and stopped at a spot hidden by crops and a row of hay. Heady's pet boxer, Doc, jumped out, and she got out and followed the dog, eager to get away from the grisly scene she knew was about to take place. Not until Hall produced a length of clothesline with which he planned to strangle Bobby did the trusting boy grow suspicious, and he started fighting violently when Hall tried to put the cord around his neck. The cord proved too short for Hall to get a good grip on, and he pulled out a pistol as he held the kicking and squirming boy down inside the station wagon. His first shot missed, but the second bullet went through the boy's head, killing him instantly. Heady complained that Hall had resorted to shooting Bobby instead of strangling him as planned, but she helped clean up the bloody mess inside the station wagon and helped load the boy's body into the back of the vehicle after Hall had wrapped it in a plastic sheet. The killers then headed back toward Kansas City with their gruesome cargo.[254]

At 11:30 a.m., when Mother Marthanna, second-in-command at Notre Dame de Sion, finished a class she had been teaching during Heady's visit, Sister Morand informed her that Bobby's "aunt" had taken him to the hospital to see his sick mother, but Sister Morand didn't know the name of the hospital. Mother Marthanna immediately called the Greenlease home to learn the name of the hospital and to inquire about Mrs. Greenlease's health. Virginia Greenlease herself answered the phone and told the nun she was feeling fine. Mrs. Greenlease quickly hung up and called her husband, and he, in turn, called the police. Kansas City police chief Bernard Brannon met Mr. Greenlease and accompanied him home, where two detectives arrived to question family members. The FBI was contacted as well, but the police did not officially announce that there had been a kidnapping until 3:00 p.m. Meanwhile, the Greenleases waited nervously throughout the afternoon.[255]

Hall and Heady stopped at a tavern in North Kansas City, where they had fortified themselves with whiskey earlier in the day prior to the kidnapping. Hall switched license plates on the station wagon while Heady went inside and had two more drinks. She also took at least one out to Hall, who did not want to go inside wearing blood-spattered clothes. The villainous pair then drove to St. Joseph and parked in the basement garage of Heady's home. Hall carried Bobby's body through the house to the backyard so that he wouldn't be seen and started burying it in the grave he had dug the day before. In the middle of the afternoon, Hall left Heady to complete the task of filling in the grave while he hurried back to Kansas City to post a ransom letter before the last mail pick-up of the day. He then drove back to St.

Joseph, stopping for drinks along the way, and once he was back at Heady's house, he and his wretched partner spent the night watching television and drinking heavily while a little boy, dead at their hands, lay buried in their backyard only steps away.[256]

Hall's ransom letter, demanding $600,000 in $10 and $20 bills gathered from all twelve Federal Reserve districts, arrived at the Greenlease home about 8:00 p.m. Hall said he knew it would take a few days to collect the stated amount of money. In the meantime, the Greenleases were to signal that they had received the ransom note by driving up and down Main Street in Kansas City between Twenty-ninth and Thirty-ninth Streets for twenty minutes with a white rag tied to their car's radio aerial. Cruelly assuring the family that Bobby was in good hands and would be returned unharmed twenty-four hours after the money was delivered, Hall said he would be back in touch later with further instructions. He signed the letter "M."[257]

The next day, Hall wrote a second ransom letter repeating the instructions of the first and enclosing Bobby's Jerusalem medal, which he had taken off the boy's body after he had killed him. Over the next day or two, he also made several calls to the Greenlease home to confirm that his notes had been received or to give further instructions. Each time, he assured the family that Bobby was all right, even making a sick joke at one point that he was "earning" his ransom because the boy was so full of mischief. Both Hall and Heady stayed drunk most of the time. On Thursday, October 1, Heady rented a 1952 Ford sedan in St. Joseph, and she and Hall then drove to Kansas City in separate cars. They abandoned the Plymouth station wagon, and Hall stole a set of license plates from a parked car and put them on the rented vehicle.[258]

Meanwhile, still holding out hope that Bobby would be returned safe and sound, the boy's father and his associates, with the personal help of President Eisenhower's brother Arthur, gathered the money demanded in the ransom notice. Little information was given out to the press, but it wasn't for lack of inquiry from reporters. The Greenlease kidnapping had become a national sensation that rivaled the 1932 Lindbergh kidnapping in the interest it aroused among the American public, and newspapers and other media reported daily on new developments in the case.[259]

After allowing a few days for the ransom money to be amassed, Hall once again contacted the Greenlease family, telephoning the home in the wee hours of Saturday morning, October 3. Over the next two days, Hall made several more calls to the home, including one in which he talked directly to Virginia

Greenlease for several minutes, and he sent the family's intermediaries on two wild goose chases, directing them pell-mell from one hidden note to another, in an attempt to arrange a drop-off that met his demands. Finally, about midnight on Sunday night, Greenlease associates Robert Ledterman and Norbert O'Neill, following Hall's latest instructions, dropped off a duffel bag containing $600,000 in currency east of Kansas City near a bridge on Lee's Summit Road about a mile south of U.S. Highway 40. After watching Ledterman and O'Neill pass by on Highway 40, Hall followed a few minutes later and made the pick-up about 12:30 a.m., lugging the duffel bag into the trunk of the rented Ford. Heady was with him in the car but was so drunk she scarcely knew what was going on.[260]

She wanted to go back to St. Joseph, but Hall, who had met two men in a Cadillac near the bridge and assumed they were the Greenlease emissaries, argued against the idea, afraid that the men had gotten the tag number and a description of the Ford. Heady finally agreed to Hall's spur-of-the-moment plan to flee to St. Louis, and the couple drove across Missouri in the early-morning hours of Monday, October 5, arriving in St. Louis about 6:00 a.m. At a tavern, Hall called his lawyer and confidant, Barney Patton, at his home in St. Joseph to ask him to somehow arrange to have the record showing Heady had rented the Ford changed or destroyed. Patton declined the assignment.[261]

Hall and Heady took a cab to another bar, and while Heady waited in the bar, Hall went to a nearby luggage store and bought a metal footlocker and a smaller suitcase. Returning to the first tavern, the pair took the money out of the duffel bag, put it in the two pieces of luggage and stuffed the duffel bag in a trash can. They placed the luggage filled with money in the Ford and then drove to another bar in the 2800 block of Wyoming Street. Hall, paranoid that the men who'd dropped off the ransom money had gotten the Ford's license number, abandoned the rental car nearby in the 2800 block of Utah Street and, soon afterward, called Patton again to tell him where the vehicle could be found. Later that morning, Hall paid cash for a 1947 Nash at a used car lot, and then he and Heady, so drunk she could barely stand up, rented an apartment in the 4500 block of Arsenal Street.[262]

Hall left Heady asleep at the apartment and started crisscrossing St. Louis, at first in the Nash but later in a series of taxicabs, frantically trying to find a place to hide the ransom money and trying to devise a scheme to throw authorities off his trail. Drinking almost constantly to calm his nerves, he grew increasingly careless and spent money rashly. A

taxi driver for Ace Cab named John Hager, who was an ex-con himself, befriended the big tipper, and he and Hall spent much of the next two days together.[263]

During the afternoon of October 6, Hager began to suspect that Hall, who had given his name as Steve Strand, was actually the Greenlease kidnapper and that the suitcases his fare had been lugging around contained the ransom money. In the official FBI version of the story, Hager called the police about 3:30 p.m. to report his suspicions, but some authors claim he instead called Joseph Costello, owner of Ace Cab and a reputed crime boss, and that Costello contacted Lieutenant Louis Shoulders, a St. Louis cop who was beholden to the mob. In either case, Hager took Hall shortly thereafter to an apartment at the Townhouse Hotel, and Hall, now calling himself John James Byrne, was arrested there by Shoulders and another officer about 7:30 p.m. on the evening of the sixth. Later that night, he directed officers to the apartment on Arsenal Street where Heady was staying, and she was arrested about midnight. Only about half of the ransom money was recovered, even though Hall swore it was all at the Townhouse when he was arrested, except the relatively small amount he had squandered, and even though the arresting officers swore they brought all the money in the apartment

Bonnie Heady and Carl Hall at the time of their arrest. *Courtesy the* St. Louis Post Dispatch.

to the police station. What happened to the other $300,000 remains a mystery to this day. Did it end up in the hands of Costello and the underworld, as some authors suggest? Was Hall lying? Or is there another altogether different explanation? No one seems to know for sure.[264]

Upon interrogation, Hall readily admitted that he had planned the kidnapping, that he and Heady had carried it out and that he had buried the boy's body in Heady's backyard; however, he maintained

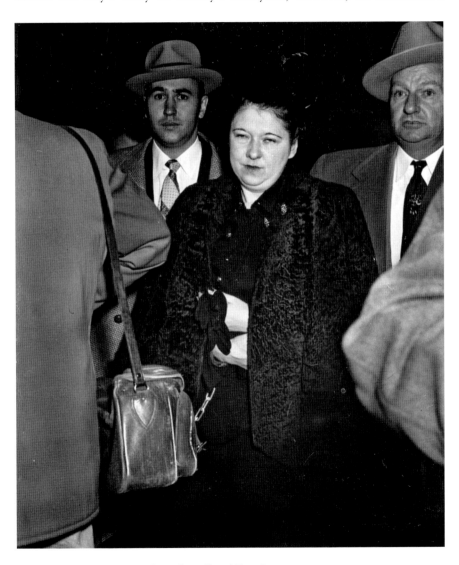

Bonnie Heady being escorted to prison. *From Missourinet.com.*

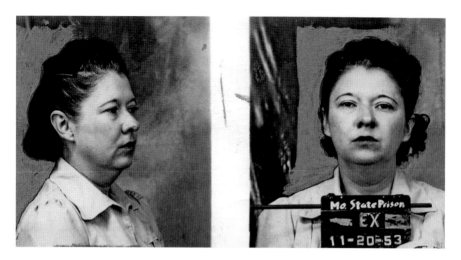

Bonnie Heady's prison mug shot. *Courtesy the* St. Louis Post Dispatch.

they had handed Bobby off to a third conspirator, Tom Marsh, after the kidnapping and that Marsh had done the killing. Bonnie Heady admitted she picked Bobby up at the school, but she said Hall had told her the boy was his son from a previous marriage. She also claimed she knew nothing about the killing, and Hall backed up her story.[265]

Bobby Greenlease's body was dug up on the morning of October 7. Memorial services were held on Friday, October 9, and he was buried in Forest Hills Cemetery.[266]

Hall finally broke down on October 11 and confessed the whole truth. Bonnie Heady also admitted her participation in the crime, including taking Bobby from the school, being with Hall when the boy was killed and helping prepare the ransom notes.[267]

Held initially on extortion charges, Hall and Heady were, after their confessions, immediately charged in federal court at Kansas City under the so-called Lindbergh kidnapping law because they had taken the child across state lines. The monstrous duo were brought to Kansas City on October 13, and appearing in court on October 30, both pled guilty to murder. The trial to determine their punishment began on November 16, and three days later, the jury recommended the death penalty for both of them. The judge set December 18 as the execution date. Although Carl Hall expressed remorse on death row for his crime, most observers dismiss his contrition as insincere. Some say Bonnie Heady, on the other hand, was truly sorry for what she had done, while others think her only regret

was that Hall had botched the crime. She reportedly told a cellmate while being held in St. Louis, for instance, that she'd rather be dead than poor and that "everything would have been all right" if Hall had stayed with her. Hall and Heady were put to death side by side in the gas chamber of the Missouri State Prison shortly after midnight on December 18. Heady, the only woman ever executed in Missouri's gas chamber, was buried the next day at a cemetery in Clearmont, Missouri, where she had gone to high school and not far from where she was born.[268]

NOTES

CHAPTER 1

1. 1850 and 1860 U.S. censuses; Shirley, *Belle Starr*, 36.
2. Shirley, *Belle Starr*, 38; *Carthage (MO) Press*, September 7, 1922; Schrantz, *Jasper County*, 187.
3. Shirley, *Belle Starr*, 39–45.
4. Harman, *Hell on the Border*, 262–63.
5. Ibid.
6. Schrantz, *Jasper County*, 186–87.
7. Shirley, *Belle Starr*, 60.
8. Ibid., 62.
9. Ibid., 67–70.
10. Ibid., 72, 75.
11. Ibid., 72–78.
12. Ibid., 78–80.
13. Ibid., 90–129.
14. Ibid., 130–37; FamilySearch.org, Kansas marriages.
15. Shirley, *Belle Starr*, 137–41.
16. Ibid., 142–65.
17. *Fort Smith (AR) Wheeler's Independent*, February 21, 1883; Shirley, *Belle Starr*, 161.
18. Shirley, *Belle Starr*, 167–92.
19. *St. Paul (MN) Daily Globe*, July 8, 1886; Shirley, *Belle Starr*, 194–202.
20. Shirley, *Belle Starr*, 206–14.
21. Ibid., 217–27.
22. Ibid., 231–33.

23. Ibid., 233–51.

24. *Butler (MO) Weekly Times*, February 13, 1889.

Chapter 2

25. Find a Grave, memorial 75966526; 1880 U.S. census.

26. Find a Grave, memorial 75966526; *Arkansas City (KS) Daily Traveler*, July 26, 1890.

27. *Joplin (MO) Sunday Herald*, November 1, 1891; *Carthage (MO) Evening Press*, October 29, 1891.

28. *Carthage (MO) Evening Press*, October 29, 1891.

29. Ibid.; *Joplin (MO) Morning Herald*, October 28, 1891.

30. *Arkansas City (MO) Daily Traveler*, October 20, 1891; *Pittsburg (PA) Dispatch*, October 29, 1891; *Fort Worth (TX) Gazette*, November 22, 1891.

31. *Carthage (MO) Evening Press*, October 29, 1891.

32. *Baxter Springs (KS) News*, October 31, 1891.

33. Ibid.

34. Ibid.; *Joplin (MO) Morning Herald*, October 28, 1891.

35. *Carthage (MO) Weekly Press*, November 5, 1891.

36. *Fort Worth (TX) Gazette*, November 22, 1891; *Kansas City (MO) Star*, November 16, 1891; Missouri State Penitentiary records.

37. *Kansas City (MO) Star*, August 16, 1895; *Wichita (KS) Daily Eagle*, January 14, 1896; Find a Grave, memorial 75966526; Missouri State Penitentiary records.

38. *Frederick (MD) News*, March 4, 1893; *Sedalia (MO) Weekly Bazoo*, June 27, 1893, quoting the *Springfield (MO) Democrat*; *St. Louis (MO) Republic*, quoted in Yesteryear News, "May Colvin."

39. *Sedalia (MO) Weekly Bazoo*, June 27, 1893.

40. *Fort Scott (KS) Weekly Monitor*, January 26, 1893; *Frederick (MD) News*, March 4, 1893; *Iron County (MO) Register*, October 27, 1892.

41. *Frederick (MD) News*, March 4, 1893.

42. *Joplin (MO) Morning Herald*, June 12, 1893; *Baxter Springs (KS) News*, June 17, 1893; *Carthage (MO) Press*, June 22, 1893; Jasper County Circuit Court Records.

43. *Carthage (MO) Press*, June 22, 1893.

44. Ibid.

45. *Goodland (KS) Republic*, June 23, 1893.

46. *Carthage (MO) Press*, June 29, 1893; Jasper County Circuit Court Records.

47. *Carthage (MO) Press*, June 29, 1893.

48. Ibid.

49. *Butler (MO) Weekly Times*, August 10, 1893; *Wellington (NZ) Evening Post*, August 26, 1893.

50. Yesteryear News, "May Colvin."
51. Ibid.
52. Ibid.
53. Ibid.
54. Missouri State Penitentiary records.

Chapter 3

55. *Roanoke (VA) Times*, September 28, 1897.
56. 1885 Kansas state census; 1880 U.S. census; *Weir City (KS) Daily Sun* (hereafter cited as *WCDS*), August 23, 1897.
57. *WCDS*, August 23 and 26, 1897; *Joplin (MO) Daily Herald* (hereafter cited as *JDH*), August 27, 1897.
58. *WCDS*, August 25 and 27, 1897; *JDH*, August 27, 1897.
59. *Pineville (MO) Herald*, August 21, 1897; Sturges, *Illustrated History*, 200–1.
60. Ibid.; *JDH*, August 22, 1897.
61. Sturges, *Illustrated History*, 200; *Pineville (MO) Herald*, August 21, 1897.
62. Ibid.
63. *Pineville (MO) Herald*, August 21, 1897.
64. *WCDS*, August 27, 1897; *JDH*, August 22, 1897.
65. *Pineville (MO) Herald*, August 21, 1897.
66. *WCDS*, August 23 and 27, 1897.
67. Ibid., August 23, 1897.
68. *WCDS*, August 23, 1897; *JDH*, August 22, 1897; *Pineville (MO) Herald*, August 21, 1897.
69. *JDH*, August 22, 1897.
70. Ibid.
71. *WCDS*, August 23, 1897; *Roanoke (VA) Times*, September 28, 1897.
72. *Roanoke (VA) Times*, September 28, 1897; *Galena (KS) Evening Times*, August 28, 1897; *WCDS*, August 25 and 26, 1897.
73. *WCDS*, August 26 and 28, 1897.
74. *WCDS*, August 27, 1897; *JDH*, August 29, 1897.
75. *Pineville (MO) Herald*, January 15, 1898.
76. *Jefferson City (MO) State Tribune*, December 28, 1904.

Chapter 4

77. James, *Love Pirate*, 16–162; *Joplin (MO) Globe*, 1917, various dates.
78. James, *Love Pirate*, 9–20.
79. Ibid., 21–24; *Joplin (MO) Globe*, February 11, 1917.

80. James, *Love Pirate*, 25–34. Many of the details of Zeo's life prior to her relationship with Thomas Cunningham, such as her receipt of $1,700 in diverted funds from B.B. Burnett's bank, derive primarily from a diary of hers that was found after her death. Although numerous quotes from the diary were cited in stories written about Zeo Zoe Wilkins shortly after her murder, the diary itself has not been located.

81. James, *Love Pirate*, 35–36.

82. *Joplin (MO) Globe*, February 9, 1917; James, *Love Pirate*, 37–39.

83. *Joplin (MO) Globe*, January 20, 1917; February 1, 7 and 11, 1917; James, *Love Pirate*, 39–40.

84. *Joplin (MO) Globe*, January 14 1917; March 9, 1917; James, *Love Pirate*, 43–44.

85. *Joplin (MO) Globe*, March 18, 1924; James, *Love Pirate*, 62–63.

86. *Joplin (MO) Globe*, January 14 and 16, 1917.

87. Ibid., January 20, 1917.

88. *Topeka (KS) State Journal*, February 21, 1917.

89. *Joplin (MO) Globe*, January 31, 1917; February 1, 1917.

90. Ibid., February 7, 1917.

91. Ibid., February 8, 1917.

92. Ibid.

93. Ibid.

94. Ibid., February 9, 1917.

95. Ibid.

96. Ibid., February 11, 1917.

97. Ibid., February 14 and 21, 1917.

98. Ibid., February 24, 1917.

99. Ibid., March 2 and 6, 1917.

100. Ibid., March 9, 1917.

101. Ibid., April 10, 1917.

102. James, *Love Pirate*, 67–75; *Joplin (MO) Globe*, March 19, 1924.

103. James, *Love Pirate*, 76–81.

104. Ibid., 82–86.

105. Ibid., 87–93.

106. Ibid., 93–96.

107. Ibid., 96–98.

108. Ibid., 165–70.

109. Ibid., 170–72.

110. Ibid., 172–73.

111. Ibid., 174–76.

112. Ibid., 176–81. In her 2009 book *The Love Pirate and the Bandit's Son*, author Laura James hypothesized Zeo's lawyer as her possible killer, but at the time of the investigation, Jesse James Jr. was never considered a prime suspect.

113. *Joplin (MO) Globe*, March 19, 1924; James, *Love Pirate*, 185–86.

114. James, *Love Pirate*, 187–96.

115. Ibid., 208, 235.

116. Ibid., 231–46.

CHAPTER 5

117. 1880, 1900 U.S. census; *Union Republican Tribune* (hereafter cited as *URT*), August 28, 1928; Morse Mill Hotel, "The Morse Mill Hotel"; Popper, "Darkness 'Round the Bend"; Jefferson County Library, Jefferson County marriage records.

118. Popper, "Darkness 'Round the Bend."

119. *URT*, August 28, 1928; Missouri State Archives, Missouri death certificates.

120. Missouri State Archives, Missouri death certificates; *URT*, August 28, 1928; 1920 U.S. census.

121. *Pacific (MO) Transcript*, March 5, 1915; Missouri State Archives, Missouri death certificates.

122. Missouri State Archives, Missouri death certificates; *Pacific (MO) Transcript*, June 10, 1927; *URT*, September 7, 1928.

123. Missouri State Archives, Missouri death certificates; *URT*, August 28, 1928.

124. Missouri State Archives, Missouri death certificates; Popper, "Darkness 'Round the Bend."

125. Popper, "Darkness 'Round the Bend"; *URT*, August 28, 1928; *Pacific (MO) Transcript*, June 10, 1927.

126. *Pacific (MO) Transcript*, June 10, 1927; Popper, "Darkness 'Round the Bend."

127. *Pacific (MO) Transcript*, June 10, 1927.

128. Missouri State Archives, Missouri death certificates; Popper, "Darkness 'Round the Bend."

129. Missouri State Archives, Missouri death certificates; *Pacific (MO) Transcript*, June 10, 1927.

130. *URT*, August 28, 1928; *Pacific (MO) Transcript*, June 10, 1927; Missouri State Archives, Missouri death certificates.

131. Popper, "Darkness 'Round the Bend"; *Pacific (MO) Transcript*, June 10, 1927; *URT*, August 28, 1928.

132. Popper, "Darkness 'Round the Bend"; Missouri State Archives, Missouri death certificates.

133. *Washington Citizen*, August 31, 1928; Popper, "Darkness 'Round the Bend."

134. *Pacific (MO) Transcript*, June 20, 1927; *URT*, August 28, 1828.

135. Ibid.; Missouri State Archives, Missouri death certificates.

136. *URT*, August 28, 1928; *St. Louis (MO) Post Dispatch*, November 20, 1928.

137. *Pacific (MO) Transcript*, June 10, 1927.

138. Ibid.

139. Ibid.; *St. Louis (MO) Post Dispatch*, November 20, 1928; Murphy, *Tainted Legacy*, 123–24.

140. *URT*, August 28, 1928.

141. Ibid.

142. Ibid.

143. Ibid.; *St. Louis (MO) Globe-Democrat*, November 21, 1928.

144. *URT*, August 28, 1928; Murphy, *Tainted Legacy*, 142.

145. *URT*, August 28, 1928; Popper, "Darkness 'Round the Bend."

146. *URT*, August 28, 1928; September 7, 1928; October 12, 1928.

147. Ibid., September 4 and 21, 1928.

148. Ibid., September 21, 1928; October 12, 1928.

149. *URT*, November 23, 1928; Murphy, *Tainted Legacy*, 95–106; *St. Louis (MO) Globe-Democrat*, November 21, 1928.

150. *URT*, November 23, 1928; Murphy, *Tainted Legacy*, 107–13; Popper, "Darkness 'Round the Bend."

151. *URT*, November 23, 1928; *Sullivan (MO) News*, December 27, 1928; Missouri State Archives, Missouri death certificates.

CHAPTER 6

152. *Joplin (MO) News Herald*, February 3, 1931.

153. Ibid.; 1910 U.S. census; Officer Down Memorial Page, http://www.odmp.org/officer/22373-chief-of-police-beldon-n-little.

154. *Joplin (MO) Globe*, January 8, 193.

155. Ibid., May 21, 1931; November 11, 1931.

156. Ibid., May 21, 1931.

157. Jasper County Records Center, undated newspaper clipping.

158. *Joplin (MO) Globe*, December 31, 1930; May 20, 1931.

159. Ibid., December 31, 1930; May 20 and 21, 1931.

160. *Carthage (MO) Press*, April 23, 1931; *Joplin (MO) Globe*, January 1, 1931.

161. *Joplin (MO) Globe*, April 26, 1931.

162. Ibid., May 21, 1931.

163. *Carthage (MO) Press*, November 11, 1931; *Joplin (MO) Globe*, November 11, 1931.

164. Jasper County Records Center, undated newspaper clipping; *Carthage (MO) Press*, May 20, 1931.

165. *Sedalia (MO) Democrat*, December 13, 1932; *Carthage (MO) Press*, January 15, 1934.

166. Duncan conversation; Ancestry.com, "Irene McCann Paroled from Prison 1936."

Chapter 7

167. Milner, *Life and Times*, 8–51.

168. Ibid., 51–52; *Joplin (MO) Globe*, December 1, 1932.

169. *Joplin (MO) Globe*, December 1, 1932.

170. Ibid.

171. Milner, *Life and Times*, 52–61.

172. *Springfield (MO) Press*, January 27, 1933.

173. Ibid.

174. Ibid.

175. Ibid.

176. Ibid.

177. Ibid.

178. Guinn, *Go Down Together*, 163–64; Barrow, *My Life with Bonnie and Clyde*, 40.

179. Guinn, *Go Down Together*, 165; *Joplin (MO) Globe*, April 14 and 15, 1933.

180. Guinn, *Go Down Together*, 165–66; Barrow, *My Life with Bonnie and Clyde*, 44–46.

181. Guinn, *Go Down Together*, 166–67.

182. Barrow, *My Life with Bonnie and Clyde*, 48–49.

183. Guinn, *Go Down Together*, 168; *Joplin (MO) Globe*, April 14, 1933.

184. Barrow, *My Life with Bonnie and Clyde*, 49–51; *Joplin (MO) Globe*, April 14, 1933.

185. Milner, *Life and Times*, 68–69; *Joplin (MO) Globe*, April 14 and 15, 1933.

186. Milner, *Life and Times*, 64; Guinn, *Go Down Together*, 138, 169; Barrow, *My Life with Bonnie and Clyde*, 52.

187. *Joplin (MO) Globe*, April 14, 1933; Guinn, *Go Down Together*, 170.

188. *Joplin (MO) Globe*, April 14, 1933; Guinn, *Go Down Together*, 169–70; Barrow, *My Life with Bonnie and Clyde*, 53–56.

189. *Joplin (MO) Globe*, April 14, 1933; Milner, *Life and Times*, 65.

190. *Joplin (MO) Globe*, April 14, 1933; Guinn, *Go Down Together*, 109–10.

191. *Joplin (MO) Globe*, April 14, 1933.

192. Milner, *Life and Times*, 66; Guinn, *Go Down Together*, 171–76; *Joplin (MO) Globe*, April 15, 1933.

193. Barrow, *My Life with Bonnie and Clyde*, 60–61; Guinn, *Go Down Together*, 177–208.

194. Milner, *Life and Times*, 89; Guinn, *Go Down Together*, 211–12; Barrow, *My Life with Bonnie and Clyde*, 110–12, 272–73.

195. Milner, *Life and Times*, 90; Guinn, *Go Down Together*, 213–14.

196. Guinn, *Go Down Together*, 214–15.

197. Ibid.; Barrow, *My Life with Bonnie and Clyde*, 116–17, 274.

198. Guinn, *Go Down Together*, 215–16; Barrow, *My Life with Bonnie and Clyde*, 119.

199. Guinn, *Go Down Together*, 216–17; Barrow, *My Life with Bonnie and Clyde*, 119–21.

200. Guinn, *Go Down Together*, 218–27.

201. Ibid., 234–62.

202. *Springfield (MO) Leader and Press*, February 13, 1934; *Stone County (MO) News Oracle*, February 14, 1934.

203. Ibid.

204. Ibid.; *Springfield (MO) News-Leader*, undated article reprinted at http://texashideout.tripod.com/reeds.html.

CHAPTER 8

205. Maccabee, *John Dillinger Slept Here*, 106.

206. Federal Bureau of Investigation, "Kidnapping of Edward George Bremer."

207. Mahoney, *Secret Partners*, 16.

208. 1880 and 1910 U.S. census; Ancestry.com, "MOLAWREN-L Archives."

209. Mattix and Helmer, "Evolution of an Outlaw Band"; *Joplin (MO) Globe*, March 9, 1915.

210. Mattix and Helmer, "Evolution of an Outlaw Band"; Federal Bureau of Investigation, "Kidnapping of Edward George Bremer."

211. Ibid.

212. Ibid.

213. *Howell County (MO) Gazette*, December 24, 1931; *West Plains (MO) Journal*, December 24, 1931; Federal Bureau of Investigation, "Barker-Karpis Gang"; Mattix and Helmer, "Evolution of an Outlaw Band."

214. *Howell County (MO) Gazette*, December 24, 1931; Mattix and Helmer, "Evolution of an Outlaw Band"; Wikipedia, "Ma Barker."

215. Maccabee, *John Dillinger Slept Here*, 60; Mattix and Helmer, "Evolution of an Outlaw Band."

216. Mattix and Helmer, "Evolution of an Outlaw Band"; Federal Bureau of Investigation, "Kidnapping of Edward George Bremer."

217. Mattix and Helmer, "Evolution of an Outlaw Band."

218. Ibid.

219. Ibid.

220. Ibid.

CHAPTER 9

221. Lowe, "Fantabulous Sally Rand"; DuNard, "Sally Rand," 99.

222. *Springfield (MO) News-Leader*, July 22, 2001; *New York Times*, September 1, 1979.

223. Lowe, "Fantabulous Sally Rand"; *New York Times*, September 1, 1979; DuNard, "Sally Rand"; *Springfield (MO) Leader and Press*, September 5, 1979.

224. DuNard, "Sally Rand"; Lowe, "Fantabulous Sally Rand"; *Newsweek*, "Sally's Sadie Proves the Fans Concealed an Actress."

225. *New York Times*, September 1, 1979; Lowe, "Fantabulous Sally Rand."

226. Driver, Letter to Fred Pfister.

227. *Newsweek*, "Sally's Sadie Proves the Fans Concealed an Actress"; *DePaulia*, September 22, 1932; *Kansas City (MO) Times*, April 7, 1972.

228. Lowe, "Fantabulous Sally Rand"; *Kansas City (MO) Times*, April 7, 1972.

229. *Columbia (MO) Daily Tribune*, October 8, 1976; Lowe, "Fantabulous Sally Rand."

230. Lowe, "Fantabulous Sally Rand."

231. *Columbia (MO) Daily Tribune*, October 8, 1976; *Kansas City (MO) Times*, April 7, 1972.

232. *New York Times*, September 1, 1979; *American Heritage*, "Fifty Years Ago."

233. *American Heritage*, "Fifty Years Ago"; *Columbia (MO) Daily Tribune*, October 8, 1976.

234. Lowe, "Fantabulous Sally Rand."

235. *Ames (IA) Daily Tribune*, February 5, 1975.

236. IMDB, *"Bolero"*; *Newsweek*, "Sally's Sadie Proves the Fans Concealed an Actress"; Knox, *Sally Rand*, 39.

237. *Newsweek*, "Sally's Sadie Proves the Fans Concealed an Actress."

238. Lowe, "Fantabulous Sally Rand."

239. *Springfield (MO) News-Leader*, July 22, 2001.

240. DuNard, "Sally Rand."

241. *St. Louis (MO) Globe-Democrat*, August 15 and 16, 1981.

242. *Newsweek*, "Sally's New Step."

243. *Columbia Missourian*, April 16, 1972.

244. *Columbia (MO) Daily Tribune*, December 17, 1975; *St. Louis (MO) Globe-Democrat*, August 15 and 16, 1981.

245. *American Heritage*, "Bottle Blonde," 26–28; *Columbia (MO) Daily Tribune*, October 8, 1976.

246. *New York Times*, September 1, 1979.

Chapter 10

247. Heidenry, *Zero at the Bone*, 4; *Joplin (MO) Globe*, September 30, 1953; Missouri State Archives, Missouri death certificates.

248. Heidenry, *Zero at the Bone*, 4; *Joplin (MO) Globe*, September 30, 1953.

249. Heidenry, *Zero at the Bone*, 4; *Joplin (MO) Globe*, September 30, 1953.

250. Heidenry, *Zero at the Bone*, 6; Missouri State Archives, Missouri death certificates.

251. Heidenry, *Zero at the Bone*, 22–24; 1940 U.S. census.

252. Heidenry, *Zero at the Bone*, 10–21.

253. Ibid., 20–27.

254. Ibid., 6–7.

255. Ibid., 32–33.

256. Ibid., 35–36.

257. Ibid., 36–37.

258. Ibid. 38–45.

259. Federal Bureau of Investigation, "Greenlease Kidnapping"; Heidenry, *Zero at the Bone*, 39–47.

260. Heidenry, *Zero at the Bone*, 48–57.

261. Ibid., 57–62.

262. Ibid., 62–66.

263. Federal Bureau of Investigation, "Greenlease Kidnapping"; Heidenry, *Zero at the Bone*, 66–84.

264. Maloney, "Greenlease Kidnapping"; Federal Bureau of Investigation, "Greenlease Kidnapping"; Heidenry, *Zero at the Bone*, 83–108.

265. *Joplin (MO) Globe*, October 8, 1953; Federal Bureau of Investigation, "Greenlease Kidnapping."

266. *Joplin (MO) Globe*, October 8, 1953; Heidenry, *Zero at the Bone*, 119–20.

267. Federal Bureau of Investigation, "Greenlease Kidnapping"; *Joplin (MO) Globe*, October 9, 1953.

268. *Joplin (MO) Globe*, October 14, 1953; Federal Bureau of Investigation, "Greenlease Kidnapping"; Maloney, "Greenlease Kidnapping"; Heidenry, *Zero at the Bone*, 127, 138, 191–92.

BIBLIOGRAPHY

BOOKS AND MAGAZINE ARTICLES

American Heritage (April/May 1983). "Bottle Blonde." Vol. 34, no. 3.

————. "Fifty Years Ago." Vol. 34, no. 3.

Barrow, Blanche Caldwell. *My Life with Bonnie and Clyde*. Edited by John Neal Phillips. Norman: University of Oklahoma Press, 2004.

DuNard, Dorothy. "Sally Rand" in *Show Me Missouri Women*. Edited by Mary K. Davis. Kirksville, MO: Thomas Jefferson University Press, 1989.

Guinn, Jeff. *Go Down Together: The True, Untold Story of Bonnie and Clyde*. New York: Simon and Schuster, 2009.

Harman, S.W. *Hell on the Border*. 1898. Reprint, Stockton, CA: Frank L. Van Eaton, 1953.

Heidenry, John. *Zero at the Bone: The Playboy, the Prostitute, and the Murder of Bobby Greenlease*. New York: St. Martin's Press, 2009.

International Movie Database. "*Bolero*." www.imdb.com/title/tt0024903.

James, Laura. *The Love Pirate and the Bandit's Son*. New York: Union Square Press, 2009.

Knox, Holly. *Sally Rand: From Film to Fans*. Bend, OR: Maverick Publications, 1988.

Maccabee, Paul. *John Dillinger Slept Here*. St. Paul: Minnesota Historical Society Press, 1995.

Mahoney, Tim. *Secret Partners: Big Tom Brown and the Barker Gang*. St. Paul: Minnesota Historical Society Press, 2013.

Mattix, Rick, and William J. Helmer. "Evolution of an Outlaw Band: The Making of the Barker-Karpis Gang." *Oklahombres Journal* 6, no. 4 (Summer 1995).

Milner, E.R. *The Life and Times of Bonnie and Clyde*. Carbondale: Southern Illinois University Press, 1996.

Murphy, S. Kay. *Tainted Legacy*. Baltimore, MD: Publish America, 2009.

Newsweek. "Sally's New Step." August 16, 1954.

———. "Sally's Sadie Proves the Fans Concealed an Actress." September 7, 1935.

Popper, Joe. "A Darkness 'Round the Bend.'" *St. Louis Magazine* (1981). In possession of Washington (MO) Historical Museum.

Schrantz, Ward L. *Jasper County in the Civil War*. Carthage, MO: Carthage Press, 1923.

Shirley, Glenn. *Belle Starr and Her Times*. Norman: University of Oklahoma Press, 1982.

Sturges, J.A. *Illustrated History of McDonald County, Missouri*. Pineville, MO, 1987.

Unpublished Sources and Government Records

Driver, Barbara. Letter to Fred Pfister. February 26, 2001. In possession of the author.

Duncan, Barry. Conversation, October 14, 2015.

Jasper County Records Center. Jasper County Circuit Court Records. Carthage, MO.

———. Undated newspaper clippings. Carthage, MO.

Online Sources

Ancestry.com. "Irene McCann Paroled from Prison 1936." http://boards.ancestry.com/thread.aspx?mv=flat&m=4883&p=localities.northam.usa.states.iowa.counties.harrison.

———. "MOLAWREN-L Archives." http://archiver.rootsweb.ancestry.com/th/read/MOLAWREN/2003-09/1063284108.

FamilySearch.org. https://FamilySearch.org.

———. U.S. Federal Census. https://familysearch.org/census/us.

Federal Bureau of Investigation. "Barker-Karpis Gang: Bremer Kidnapping." https://vault.fbi.gov/barker-karpis-gang/bremer-kidnapping/bremer-kidnapping-part-49-of.

———. "The Greenlease Kidnapping." FBI files. www.fbi.gov/about-us/history/famous-cases/greenlease-kidnapping.

———. "Kidnapping of Edward George Bremer." FBI files. https://vault.fbi.gov/barker-karpis-gang/bremer-investigation-summary/Barker-Karpis%20Gang%20Summary%20Part%201%20of%201.

Find a Grave. www.findagrave.com.

Jefferson County Library. Jefferson County marriages, newspaper index. www.jeffcolib.org.

Lowe, Jim. "The Fantabulous Sally Rand." http://www.yodaslair.com/dumboozle/sally/sallydex.html.

Maloney, J.J. "The Greenlease Kidnapping." *Crime Magazine.* missourideathrow.com/do-history/the-greenlease-kidnapping.

Missouri State Archives. Missouri death certificates, 1910–1964. http://s1.sos.mo.gov/records/archives/archivesdb/deathcertificates/Default.aspx#searchDB.

———. Missouri State Penitentiary records. http://s1.sos.mo.gov/records/archives/archivesdb/msp.

Morse Mill Hotel. "The Morse Mill Hotel." www.morsemillhotel.com.

Officer Down Memorial Page. www.odmp.org.

Wikipedia. "Ma Barker." https://en.wikipedia.org/wiki/Ma_Barker.

Yesteryear News. "May Colvin." *Yesteryear Once More.* https://yesteryearsnews.wordpress.com/tag/may-colvin.

Newspapers

Ames (IA) Daily Tribune.
Arkansas City (KS) Daily Traveler.
Baxter Springs (KS) News.
Butler (MO) Weekly Times.
Carthage (MO) Evening Press.
Carthage (MO) Press.
Carthage (MO) Weekly Press.
Columbia (MO) Daily Tribune.
Columbia Missourian.
DePaulia.
Fort Scott (KS) Weekly Monitor.
Fort Smith (AR) Wheeler's Independent.
Fort Worth (TX) Gazette.
Frederick (MD) News.
Galena (KS) Evening Times.
Goodland (KS) Republic.
Howell County (MO) Gazette.
Iron County (MO) Register.
Jefferson City (MO) State Tribune.
Joplin (MO) Daily Herald.
Joplin (MO) Globe.

Joplin (MO) Morning Herald.
Joplin (MO) News Herald.
Joplin (MO) Sunday Herald.
Kansas City (MO) Star.
Kansas City (MO) Times.
New York Times.
Pacific (MO) Transcript.
Pineville (MO) Herald.
Pittsburg (PA) Dispatch.
Roanoke (VA) Times.
Sedalia (MO) Democrat.
Sedalia (MO) Weekly Bazoo.
Springfield (MO) Leader and Press.
Springfield (MO) News-Leader.
Springfield (MO) Press.
Stone County (MO) News Oracle.
St. Louis (MO) Globe-Democrat.
St. Louis (MO) Post Dispatch.
St. Paul (MN) Daily Globe.
Sullivan (MO) News.
Topeka (KS) State Journal.
Union (MO) Republican Tribune.
Washington (MO) Citizen.
Weir City (KS) Daily Sun.
Wellington (NZ) Evening Post.
West Plains (MO) Journal.
Wichita (KS) Daily Eagle.

Index

ABOUT THE AUTHOR

L arry Wood is a retired public school teacher and a freelance writer. His historical articles have appeared in numerous publications, including *America's Civil War*, *Blue and Gray*, *Gateway Heritage*, *Missouri Life*, *Missouri Historical Review*, the *Ozarks Mountaineer*, *True West* and *Wild West*. He has published six other titles with The History Press: *Civil War Springfield*; *The Two Civil War Battles of Newtonia*; *Wicked Joplin*; *Wicked Springfield, Missouri*; *The Siege of Lexington, Missouri*; and *Murder and Mayhem in Missouri*. A native of Fair Grove, Wood received his bachelor of arts and master of arts degrees from Missouri State University and now lives in Joplin with his wife, Gigi.

Visit us at
www.historypress.net

···

This title is also available as an e-book